IMAGES
of America

WILTON, TEMPLE, AND LYNDEBOROUGH

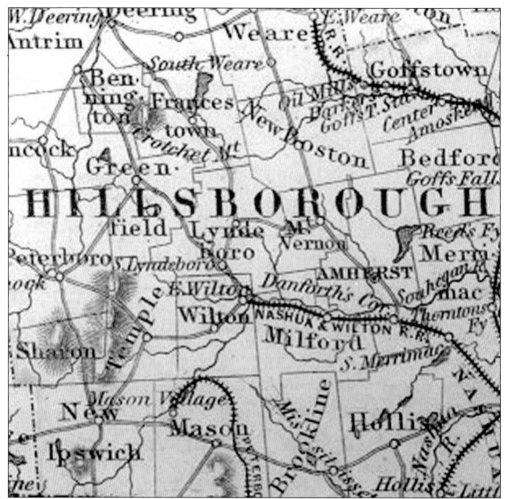

Wilton, Temple, and Lyndeborough are shown in a detail from an 1855 map of New Hampshire.

IMAGES
of America

WILTON, TEMPLE, AND LYNDEBOROUGH

Michael G. Dell'Orto, Priscilla A. Weston,
and Jessie Salisbury

ARCADIA

First published 2003
Reprinted 2003

Published by Arcadia Publishing,
an imprint of Tempus Publishing Inc.
Portsmouth NH, Charleston SC, Chicago,
San Francisco

Printed in Great Britain

Library of Congress Catalog Card Number: 2003104547

For all general information, contact Arcadia Publishing:
Telephone 843-853-2070
Fax 843-853-0044
E-mail sales@arcadiapublishing.com
For customer service and orders:
Toll-free 1-888-313-2665

Visit us on the Internet at www.arcadiapublishing.com

CONTENTS

Acknowledgments 6

Introduction 7

1. Wilton 9

2. Temple 49

3. Lyndeborough 89

ACKNOWLEDGMENTS

Many people were responsible for the collection and preparation of the material for the Wilton section of this book. Special thanks must go to the members of the Wilton Historical Society. Its president, David Vincent, with Phyllis Tallarico and P. Jane Bergeron, archivists and curators of the society's collections, did the lion's share of the work selecting the photographs and supplying information for the captions. In addition, we wish to thank the following people for lending us their photographs, their knowledge of town history, and their wisdom and advice: Richard Putnam, Jean Vincent, Stanley Young, Lynne Draper, Marguerite Hardy, Jo Ann Lajoie, John Hutchinson, Harland and Pamela Savage, Pat Perkins, David Potter, Coni Porter Designs, Thomas Schultz, and the staff of the Wilton Public-Gregg Free Library.

Priscilla Weston, curator of the Temple Historical Society since the 1970s, collaborated with Anne Lunt, its president, in selecting the pictures and writing the text for the Temple chapter of this book. While most of the postcards and photographs belong to the society's collection, the authors would like to thank the following people and organizations for filling in gaps with important pictures: the Peterborough Chamber of Commerce, the Peterborough Transcript, and Ruth E. Quinn.

The Lyndeborough Historical Society greatly appreciates the loan of pictures from the following people: Rosie Howe, Elizabeth Raymond, Bea Wilcox, Dale Russell, Allan Morrison, Lucy Schmidt, Roger Foote, Guy Reynolds, Marilyn Ercoline, and Carma Holt.

INTRODUCTION

In 1735, the commonwealth of Massachusetts granted several townships within a territory under dispute with New Hampshire as payment to soldiers who had taken part in the ill-fated expedition against Canada in 1690. These townships were called "Canada Towns." One of them, a township six miles square, was granted to residents of Salem and became Salem-Canada. Salem-Canada contained most of what is now Lyndeborough, a large section of Wilton, and about 900 acres of Temple.

In addition to their common beginnings, the three towns share several municipal services. The three towns share an ambulance-rescue service and a recycling center. Wilton and Lyndeborough formed a cooperative junior-senior high school in 1968. Prior to the establishment of the cooperative, most Lyndeborough students and some Temple students attended Wilton High School, which is now part of Wilton's elementary school complex. Temple is part of the Contoocook Valley Regional School District centered in Peterborough.

Wilton and Lyndeborough also share a youth center featuring a summer swimming program and other sports. The towns share a conservation area on Carnival Hill, the site of winter carnivals and a toboggan chute that was once featured in *Ripley's Believe It or Not* because it was located within three towns: Wilton, Lyndeborough, and Milford. They have a joint Wilton-Lyndeborough Women's Club. Scouting and other youth activities, such as the Wilton Junior Athletic Association, frequently include young people from both towns.

Each of the three towns began with a meetinghouse in the geographical center and a village that grew up around it, including a school, the store, the tavern, and the post office, as well as the blacksmith and other tradespeople. Wilton and Lyndeborough still have these central villages with church and the fine old houses, but the population centers have moved elsewhere, with advances in manufacturing technology and methods of transportation. Temple, lacking an early direct influence of a major highway or railroad, has retained its first village as the town business and cultural center.

All three towns continue to hold traditional town meetings, but some school districts have changed to the new Official Ballot Law system.

In Lyndeborough, the advent of the Forest Road in the 1830s began the move of commerce to South Lyndeborough, a move completed by the railroad in 1873. North Lyndeborough developed a village with tavern and post office with the opening of the Second New Hampshire Turnpike in 1780. When the railroad replaced the horse-drawn wagons, this village, too, faded away.

In Wilton, the first move away from the hilltop central village was to West Wilton, with the development of water power for several mills. West Wilton Village had a store, a stagecoach inn, a school, a bandstand, a muster field for the militia, and (later) a gas station. All are now gone.

In 1851, the railroad arrived in East Wilton, now the downtown area, where the railhead remained until 1873, when the line was extended west through Lyndeborough to Hillsboro. The new town hall was built in East Wilton in 1885, and a new central high school was constructed in 1896. Textile mills were built along the Souhegan River, and other industries followed.

Temple continues to have only one central village with municipal services there, as well as the store. The town office and grade school have moved outside a little way but remain close. The town's last one-room school has been moved to the central village to become the home of the historical society.

The towns have all changed and grown but have, in many ways, remained the same.

One

WILTON

*Maria Wilton lives in the pretty white house which stands just at the entrance
of the wood. . . . It is not as large or elegant a house as many as we pass
on a walk through the village, but . . . its appearance is quite as inviting
as that of many a more splendid mansion. Neatness and good order
regulate all the arrangements of the family. . . . Peace and harmony
characterize the intercourse of the inmates. It is seldom that confusion
or uproar, or disputes or contentions, are known among the Wiltons.*
—Jacob Abbot, *Rollo at Play*, 1855

So begins a little story-within-a-story in one of the series of very popular children's books known as the Rollo stories, by Wilton author Jacob Abbot. By naming the family in this story the Wiltons, perhaps Abbot was trying to make a statement about the town in which he was born and raised (and at that time resided), a town that his family (including several Revolutionary War heroes, college professors, ministers, and a headmaster of Phillips Exeter) had helped settle. The story of Wilton is typical of the many hill towns of New Hampshire; it began life as part of the larger area known as Salem-Canada (see the general introduction to this book) when Jacob and Ephraim Putnam, John Badger, and John Dale carved primitive homesteads out of the wilderness in 1739. In 1749, this section of Salem-Canada, now called Number Two, was part of a royal grant to John Tufton Mason and several other proprietors. It was surveyed and lots parceled out, with several reserved for mills, schools, and the church. By 1762, the town was incorporated as Wilton, named presumably after the ancient borough town in Wiltshire, England. Its spiritual, commercial, cultural, and political life was focused around the common and the meetinghouse in Wilton Center. Two other villages eventually arose: West Wilton, on the road to Temple, and the East Village, near the Souhegan River on the road to Milford. It was largely a farming community with a few water-powered mills for lumber, grain, or potato starch serving the needs of the farmers. By 1820, however, several enterprising men of the community had already been building mills for the manufacture of woolen goods.

By 1850, like many towns in the region, Wilton had begun to shift away from agriculture to manufacturing, now that raw goods could be brought in from all over and shipped out as finished materials via the new railroads. Wilton prospered, and the center of commerce and politics shifted to the East Village, near the river and the railroad. Names such as Colony, Whiting, and Abbot came to figure prominently, as more and more mills were built to make

cloth, furniture, or wooden boxes. Dairy farming began to grow, since the railroad allowed for a morning milk run to Boston in just over an hour. The old center of town, almost abandoned for a time, became the locus of a new summer community, as folks from Boston or New York bought many of the old homes and built some new ones. There were hotels in the East Village to accommodate the many tourists who came up to Wilton to experience a bit of country life or to attend the Winter Carnival. The beauty of the area drew artists such as Chauncey Ryder, Hobart Nichols, Ross Turner, and Roy Brown. By the 1960s, the mills were moving south and the high-tech revolution that would transform southern New Hampshire for good and for ill was on the horizon.

Through it all, the one constant is the community—a community with a rich history and traditions. The photographs in these pages detail much about who we were and what life was like in Wilton in the generations past. In some way, we hope that a knowledge of that history and those traditions will serve all of us who are charged with seeing our little town through the 21st century.

We are, as Jacob Abbot astutely observed, not the largest or most elegant house on the block, but we are special, and life here is good.

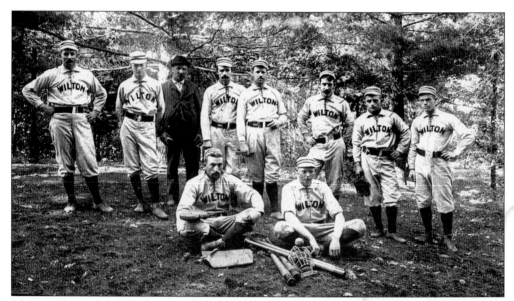

The members of the Wilton men's baseball team pose c. 1890. Ten men are shown in the photograph, but only eight names are written on the back. Charlie Balcom, the manager, is probably the man in the suit. Arthur Young is standing sixth from the left. The others are Rev Mitchell, William Kennedy, George Bales, Charles Lucas, Joe Curtis, and Stan Center.

This is a view of Wilton Village (also called the East Village) *c*. 1876. The photograph shows the village not long after the first of three fires that destroyed most of Main Street. It was taken prior to the building of the town hall, the library, and the new Masonic hall.

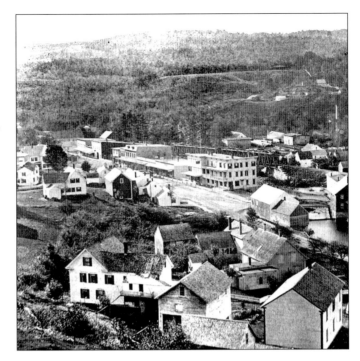

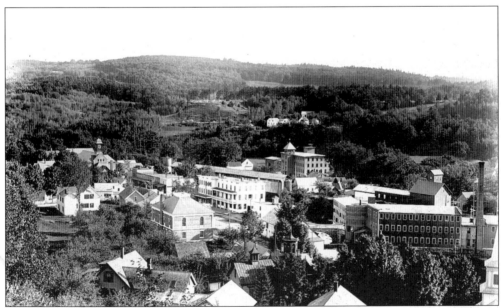

Prominent in this *c*. 1899 photograph of the East Village are the newly built Masonic hall, the clock tower of the new town hall, the Everett Hotel, and the steeple of the Second Congregational Church (lower right). Also shown are several mill buildings—the Colony (later the Amidon and, still later, the Abbot Worsted) Mill, the Whiting Box Manufacturing Company, and the Whiting Grain Mill. The predominance of these buildings in the photograph shows that Wilton, like many New England towns at the start of the 20th century, was first and foremost a mill town.

This view of West Wilton Village shows the old print shop (center), owned by the Ring family and now gone; the pond; and the twin brick Federal houses built by Samuel Smith c. 1820. The building just visible through the trees to the left was the first Baptist parsonage in Wilton.

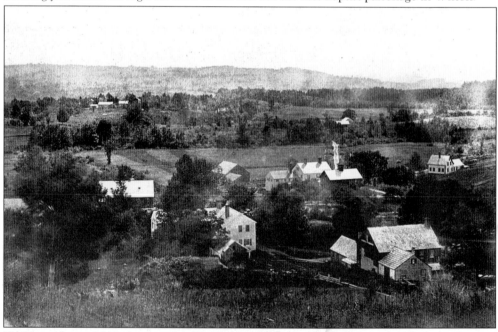

Visible in this c. 1860 photograph of the Davisville section of Wilton is the Eliphalet Putnam House (left foreground), the Dascomb Mill (right foreground), Daniel Cragin's (now Frye's) Mill (left background), and the Daniel Cragin homestead (right background).

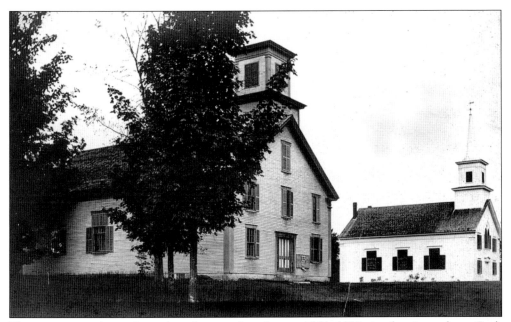

The interesting thing about this photograph, taken *c*. 1891–1892, is what is *not* here. Both buildings—the Advance Grange Hall (left) and the church of the First Unitarian Congregational Society of Wilton Center—sit beside each other with an empty space between them. That space was, by all accounts, the site of Wilton's second meetinghouse. Built in 1773, the meetinghouse burned in 1859.

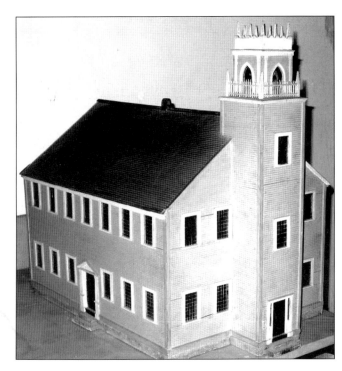

This model of Wilton's second meetinghouse was built by Henry Holt prior to 1888. Holt, born in 1839, was a young man when the building burned in 1859.

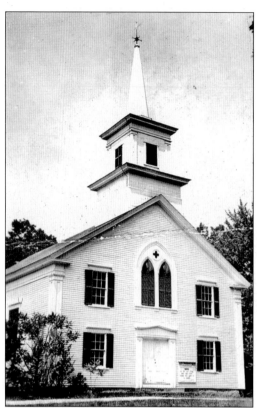

The Wilton Center First Unitarian Congregational Society Church was built in 1860 after the town's second meetinghouse burned to the ground in 1859.

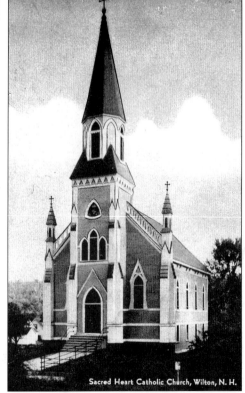

Sacred Heart Catholic Church was built in 1881. The first pastor in residence was Fr. E.E. Buckle.

Located on Tremont Street, the Wilton Episcopal Church also served, at various times, as a school for special education students (the Little Red Schoolhouse) and as a town equipment shed. The building is now a private residence.

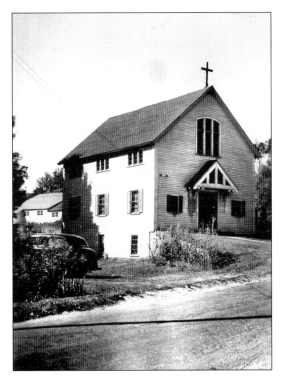

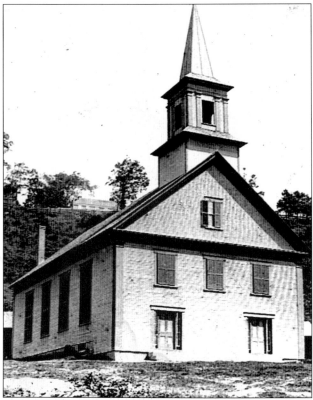

The Second Congregational Church was created when a group split from the First Congregational Society and built a small building in Wilton Center in 1829. (A stone monument in the woods marks the location.) The congregation built this church c. 1852 in the East Village.

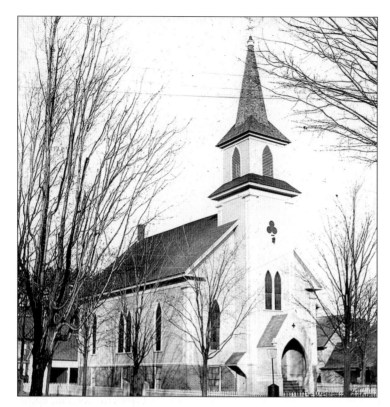

The Unitarian (Liberal Christian) church was built in 1869, in the East Village. After the congregation dispersed, it was sold to the American Legion, and it served as a hall for that organization after World War II.

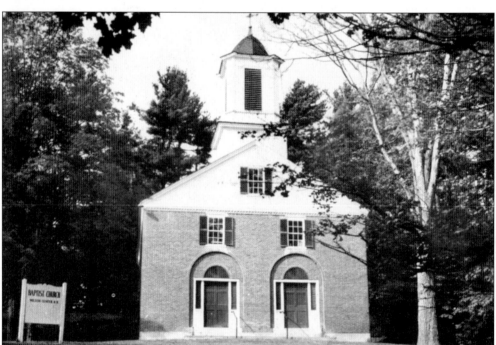

Built in 1827, the Baptist church in Wilton Center is the oldest public building still standing in town. The sanctuary of the church still contains the original box pews and kerosene chandeliers.

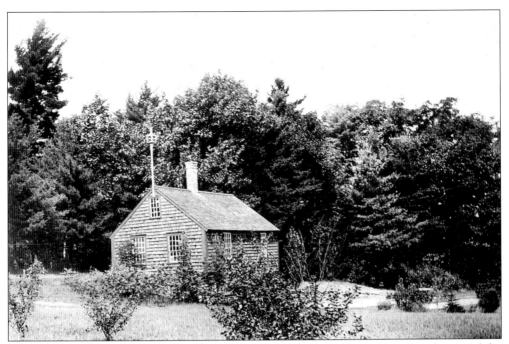

The Ephraim Putnam House, possibly the first house built in Wilton, is certainly one of the oldest houses still standing in town. Ephraim Putnam was one of the first settlers of Wilton in 1739, along with Jacob Putnam, John Badger, and John Dale. The house originally stood at intersection of the roads by Vale End Cemetery in what is called the Davisville section, but it has since been moved farther up Davisville Road and has been restored.

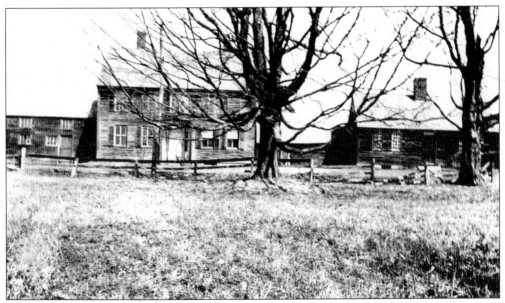

The Jonathan Cram farm is seen in the early 20th century. The original building (the small Cape to the right) was built c. 1760 and was enlarged over the years. In 1939, Beulah Emmett purchased the property and established High Mowing, a Waldorf school, which occupies the property today. These buildings comprised the main campus until they burned in a fire.

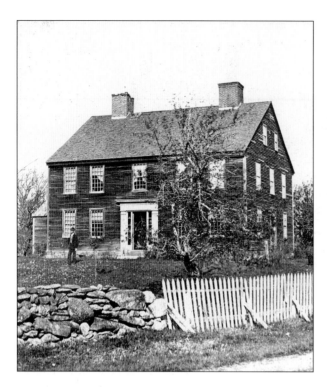

The Livermore Manse, built *c.* 1765 on Russell Hill, was home of the first settled minister in Wilton—Jonathan Livermore, who was ordained first minister of the Congregational church on December 14, 1763.

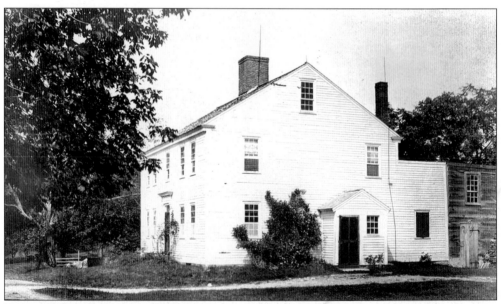

Dating from *c.* 1760, the Herman Abbott Homestead and Farm (also called the Four Corners Farm) is another of the earliest houses built in Wilton. It still sits prominently atop Abbott Hill.

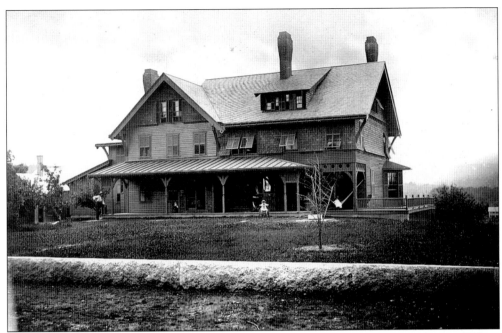

These two houses stood opposite each other at the crossroads near the common in Wilton Center for many years. The view above shows the house that is still standing; its basic structure was built by Richard Taylor Buss as early as the late 1700s. The photograph, taken *c.* 1895, shows how the house had grown and changed in the space of a century. The other house was known as the Boynton House for Oliver Boynton, who resided there for many years. It was built *c.* 1832 by Asa Jones, who owned a shoemaking facility in the center. It was demolished to make way for the house built *c.* 1909 by David Gregg as a summer residence, which still stands today.

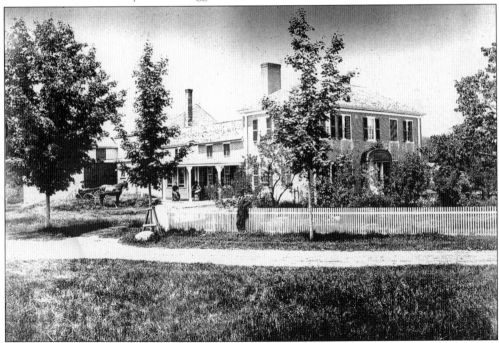

The Sheldrick House was the site of one of the three murders committed in town. In 1890, Warren Holt was bludgeoned to death here by his son Edwin W. Holt. Edwin, found by the court to be deranged, was committed to an asylum, where he died less than one month later.

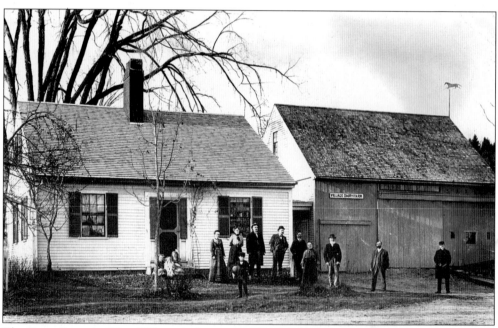

The Keyes Farm, in West Wilton, is shown c. 1890. Frank Clement, who lived in the house in the 1920s, committed suicide when Warren Harding was elected president over James M. Cox. Clement believed that Harding's policies would lead to financial ruin for the nation. He was off by only two presidents.

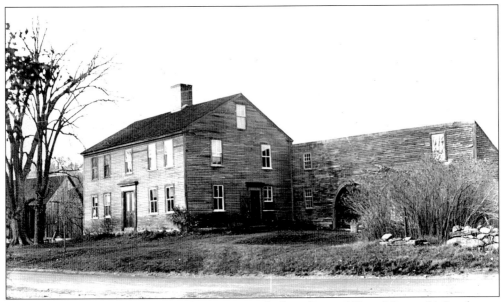

Before there was a state highway, the area around where Route 101 and Route 31 South now intersect (Gray's Corner) was a small settlement just down the hill from Wilton Center. This is the Mansur House (built by Ephraim Peabody *c.* 1770), which occupied the piece of land between Mansur Road and Route 101 near where Monadnock Mountain Spring Water now stands. It was named after Stephen Mansur, who bought the house from the Peabodys in the early 1800s.

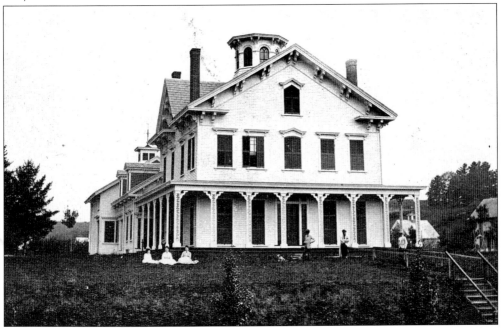

Many wealthy residents constructed elaborate houses near the East Village in the mid- to late 1800s as the mills and the railroad became the focus of the town's prosperity. This is the Beard House on Burns Hill. Built in the Italianate style by Boston merchant Luke Beard, the house occupied a spot known as Highland Circle above the village.

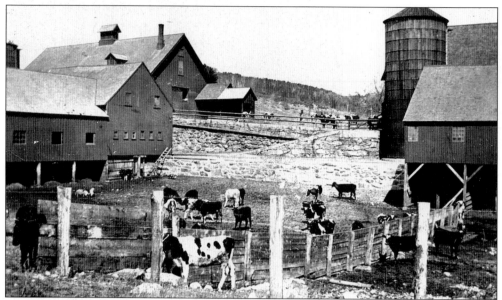

The Hampshire Hills Dairy Farm (shown c. 1940) began as David Whiting and Sons Dairy in 1857, after Whiting bought out the previous owner. From the 1930s until the 1960s, Hampshire Hills was a major dairy operation with a modern milk-processing plant. The dairy collected milk from many area farms for shipment to Boston.

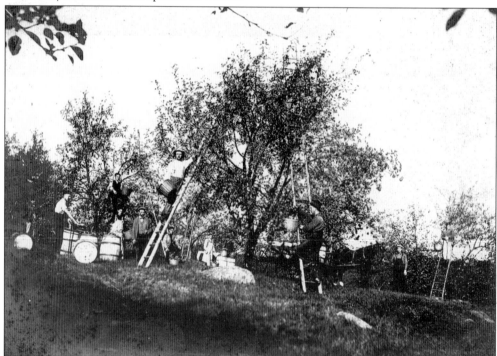

Apple growing was a huge industry in Wilton and in the whole region. This c. 1900 photograph could be of any one of the many orchards in town: Holt's, Heald's, Whiting's, Batchelder's, Pomme-a-Lane, or Badger Farms. Only a very few remnants of these large commercial orchards still survive.

This is the only picture of a residential interior in the historical society collection. A note on the back of the photograph says, "Ollie Hutchinson House." It is most likely the parlor of the house that F.S. Hutchinson built in 1879 after vacating the house and store pictured below.

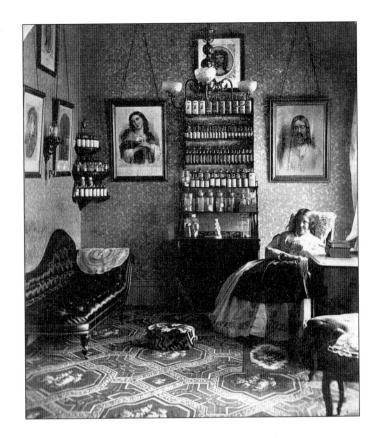

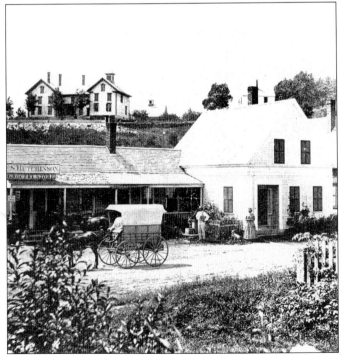

F.S. Hutchinson's store and residence on Forest Road is pictured c. 1870. Hutchinson owned and operated this store from the early 1860s to 1879, when he built a new house and store on the corner of Forest Road and Dale Street. The house on the hill in the background is the residence (rear view) of Hon. Charles H. Burns, a noted Nashua lawyer for whom Burns Hill is named.

This is the home and barn of Philander Ring, in West Wilton. Ring owned and operated Ring's Ambrosia Company, which made ointments that were sold all over the country and in many parts of the world. When a worker tending a kettle of boiling Vaseline in the barn left his post to pop over to the tavern for a quick refresher, the vat caught fire, quickly consuming both the barn and the house.

This view shows the Parkhurst Farm c. 1916. Built c. 1789 by Jonathan Parkhurst (town constable for several terms), the house remained in the Parkhurst family for four generations. The photograph shows the two sections of the house as it grew over time. The main building, in the center, is a later Federal-era addition to the original structure, which is to the right at the rear of the house and includes the carriage sheds.

These buildings, formerly the David Whiting Farm, were sold to Hillsborough County in 1868 for use as the county poor farm. The county operated the farm on this site until 1895.

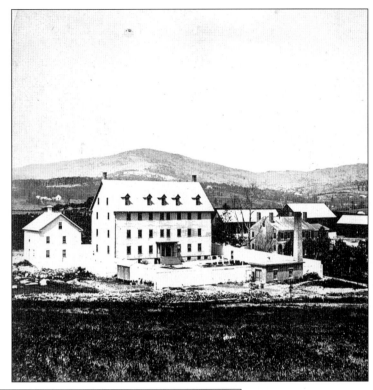

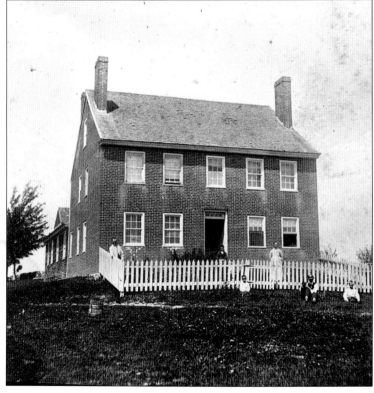

Seen *c.* 1860, the Wilton Town Farm (originally the Nathan Whiting Farm) was built *c.* 1815 in West Wilton. Whiting sold the property to the town in 1830, and it served as the town poor farm until 1868.

25

This building has served many functions throughout the years since it was constructed *c.* 1800 by Richard Taylor Buss. Called the Brick Hall or Brick Store, it served variously as a meeting hall for social and political events. It was the first Masonic hall in Wilton and was a store operated by Joseph Newell. At one time, it was converted into a residence and was the home of the family of William French Smith, U.S. attorney general. Today, it serves as the office, library, and meeting space for the Unitarian church.

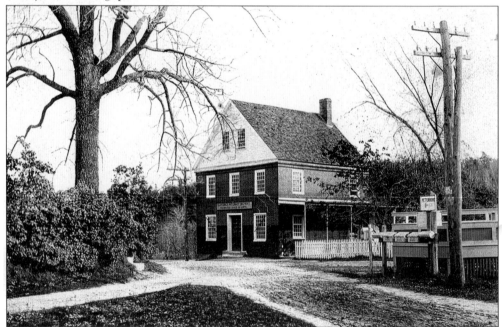

The West Wilton General Store, built by Samuel Smith *c.* 1825, is seen here with the bandstand. The store (also a residence) was the center of West Wilton village life and continued in operation until 1966.

The Tavern in West Wilton was built *c.* 1825 by Samuel Smith. Smith and his brother Joseph were largely responsible for the growth of West Wilton as a manufacturing center. They built several mills, as well as this inn, which served as a major coach stop until the railroad came through the East Village.

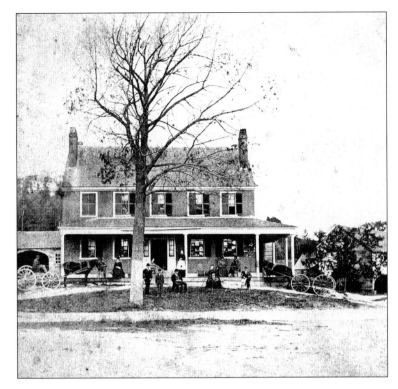

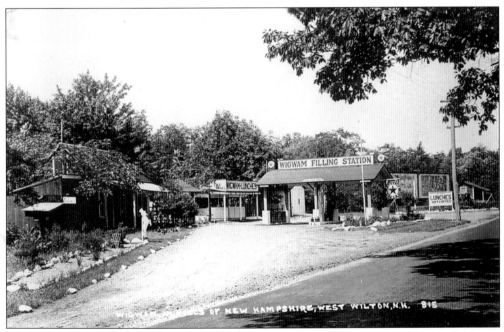

The Wigwam gas station is shown in 1934. This popular tourist stop was at the head of West End Highway (the road to West Wilton) near the spot where Gary's Harvest Restaurant is today. Cabins were offered for rent, and several of them survive on the site today.

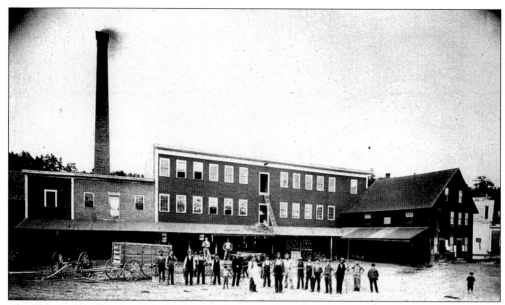

The Whiting Mill, seen c. 1880 in a view from the mill yard, manufactured wooden boxes of all varieties. The newly built Wilton Police Station now occupies the spot, which had been vacant since the mill was torn down in the 1960s.

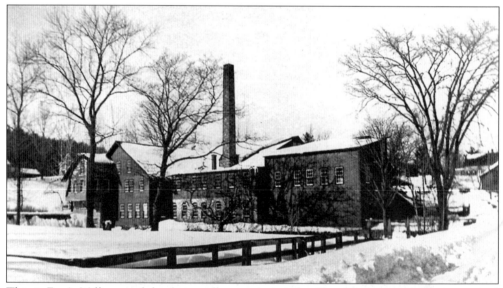

This is Frye's Mill, one of the few small water-powered mills still operating with its original machinery in New England. Built by Eliphalet Putnam in 1817 on the site of an earlier building, it originally made wool-carding combs. In 1858, Daniel Cragin bought out Putnam and built an addition to the original mill, where he began to make wooden measures, toys, and knife trays. The mill was subsequently sold to E.B. Frye and his son Whitney in 1909.

The Davis Mill, established in 1863, was carried away by a flood in 1869. This mill and several others were located on the Souhegan River in a place called French Village, which is the area near the current Intervale Road. The Davis Mill site is located by the old bridge over the river, opposite the Wilton Recycling Center.

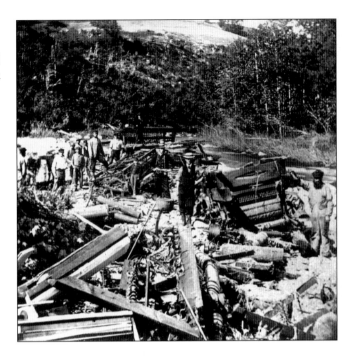

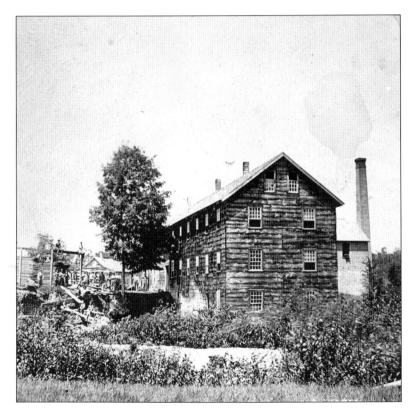

Peter Putnam's shop was formerly the Killiam and Emerson furniture mill. It was located in French Village about halfway down the current Intervale Road on the river side of the road.

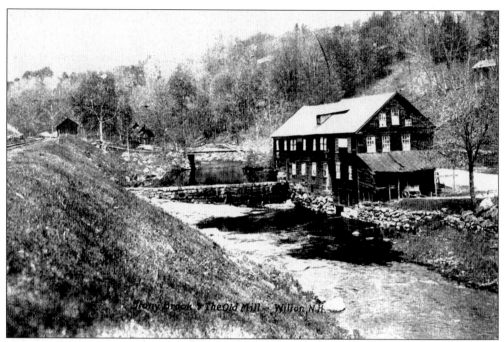

The Old Mill on Stoney Brook, seen *c.* 1900, was originally Levi Putnam's trunk factory, built *c.* 1850. The mill was later the Alfred Curtis Cider mill, which burned in 1939. It was rebuilt and subsequently used as the Boy Scout hall.

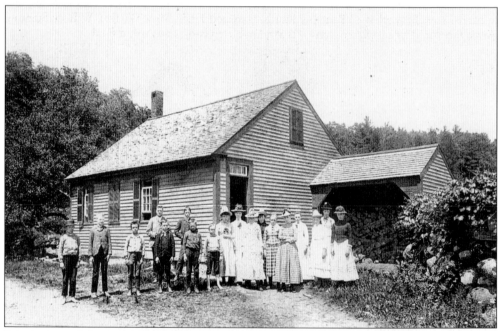

Prior to consolidation of the elementary schools in the East Village in the 1930s, there were nine school districts in town, each with its own one-room schoolhouse. This is the West Wilton School *c.* 1885. The teacher is identified as Miss Herlihy.

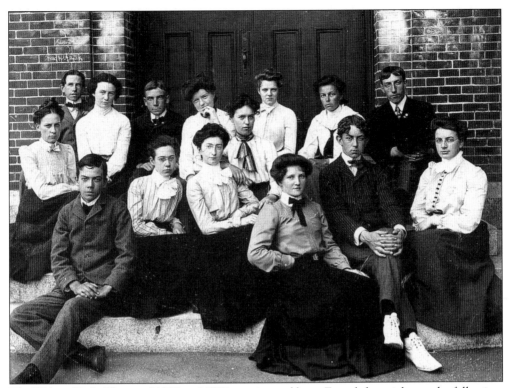

The Wilton High Classes of 1902 and 1903 are pictured here. From left to right are the following: (front row) John Stanton, Lucie Stiles, Mollie McKenna, Emma Herrick, Harold Bales, and Winifred French; (back row) Beulah Edwards, Harwood Tracy, Mary Whalen, William Stanton, Anna Proctor, Bessie Dolliver, Bessie Hartshorn, Helen Ring, and Arthur Purdy.

District No. 9 School (Intervale) is shown in a photograph dated 1866. The teacher is Martha E. Mason. According to the school report for 1866, it was her first year teaching there, and the report remarks on her exemplary work. After the district schools were consolidated in the 1930s, this building was dismantled and moved to Abbott Hill by Charles Frye, who converted it into a dwelling.

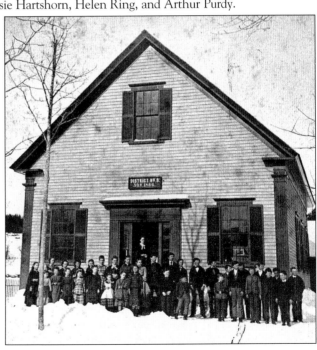

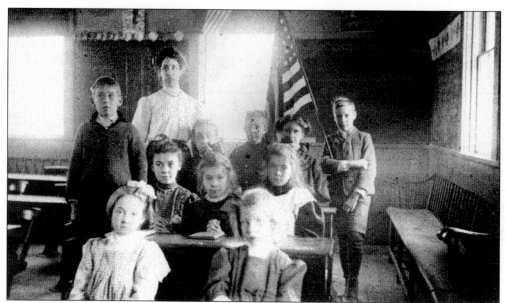

Taken in 1906 or 1907, this photograph offers a rare interior view of the Abbott Hill School, one of Wilton's one-room schoolhouses. The teacher is Harriet Cooper. The others are, from left to right, as follows: (front row) Florence Rideout (who later taught in the Wilton schools and after whom the elementary school is named) and Grace ?; (middle row) Grace Chandler, Doris Potter, and Marion Abbot; (back row) Cora Abbot, Howard Abbot, and Lora Chandler. Standing are Lynn Potter and Leonard Abbot (with flag).

William French Smith, former U.S. attorney general, and his sister Mary (right) are shown with Florence Rideout, their elementary school teacher. The Smith family owned what is now the Unitarian Red House in Wilton Center, and the future attorney general attended the one-room schoolhouse there. Florence Rideout taught for more than 40 years in the Wilton schools. After her death, the elementary school in the East Village was named in her honor.

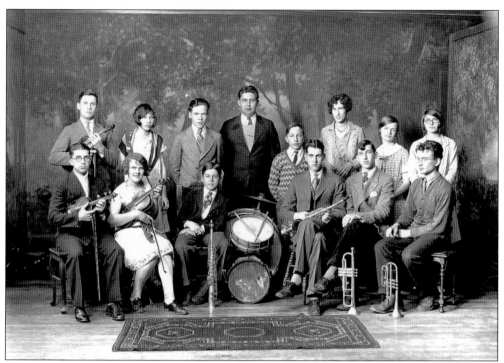

The Wilton High School band poses in this photograph dated April 25, 1929. From left to right are the following: (front row) Joe Jarest, Beverly Dunbar, Sam Abbott, Bill Broderick, Ham Putnam, and Jonathan P. Ring; (back row) William Abbott, Marian Locke, Calvin Locke, Gordon Powers, Maynard Batchelder, ? Bowen, Francis Ring, and Dorothy Cheever.

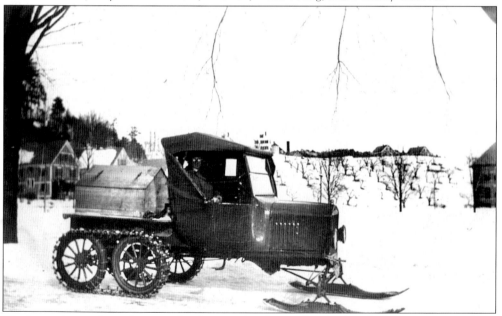

We do not know about the rain, the sleet, or the gloom of night, but the snow was no problem with this snazzy snowmobile used by Harry Hutchinson to complete his appointed rounds as a rural free delivery carrier in 1926.

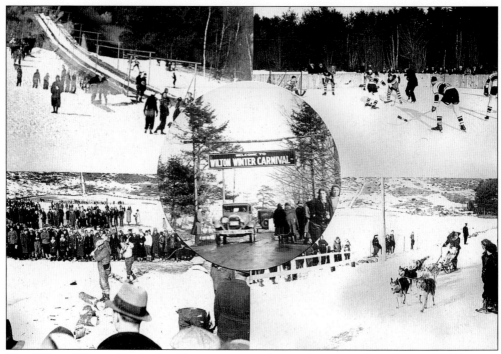

The Wilton Winter Carnival, with venues in and around town and on Carnival Hill, was a major New England event for 10 years, beginning in 1926. Several trains per day from Boston and Worcester brought people from all over, both to view and to participate in competitions in skiing and other winter sports. Medals and ribbons were awarded, and the toboggan run made it in to *Ripley's Believe It or Not* because it passed through three towns: Wilton, Milford, and Lyndeborough.

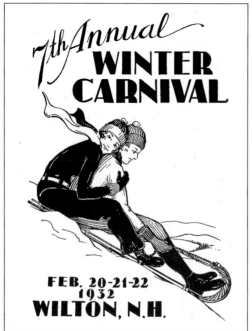

The 1932 Winter Carnival program cover was done by artist Carl Nelson, who also designed store window displays for Jordan Marsh in Boston. Nelson did the original mural (recently re-created and replaced) on what was Luther Langdells's auction barn downtown, now the Intervale Machinery building.

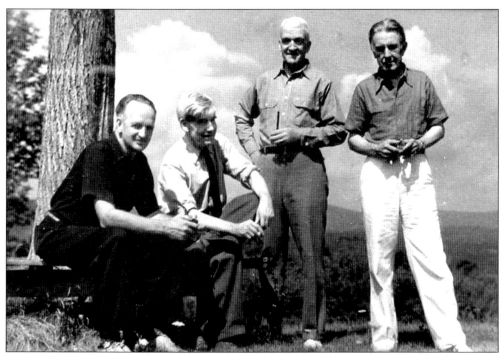

Seen in this rare photograph (probably from the 1930s) are, from left to right, Stanley Woodward, Chauncey Ryder, Roy Brown, and Hobart Nichols. These prominent artists all owned or rented summer residences in Wilton. Their work was, in many ways, inspired by the natural beauty they saw around them here in Wilton.

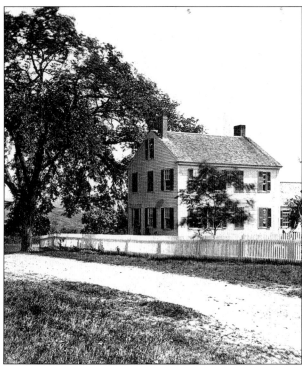

Dr. Timothy Parkhurst's house was built c. 1801. Parkhurst was one of the first physicians to reside in Wilton. The house was moved across the road from its original site, which was near the present-day site of the Girl Scout Camp Anne Jackson. Painter Roy Brown, one of several nationally renowned artists who resided in Wilton, lived there for a time.

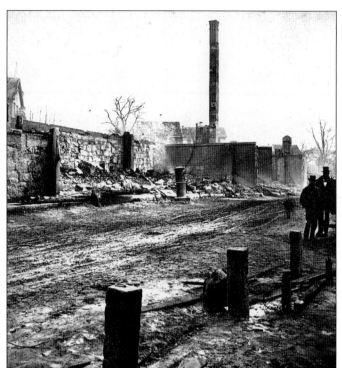

In 1874, 1881, and 1885, there were three major fires that destroyed Main Street. In the upper left corner of this view, the steeple of Catholic church is just visible. The 1881 fire occurred in January, and the church was erected in the fall of 1881, so it is possible that 1881 is the year of this photograph. However, the damage shown here looks recent, not nine or more months after the fact, so this may be the aftermath of the 1885 fire.

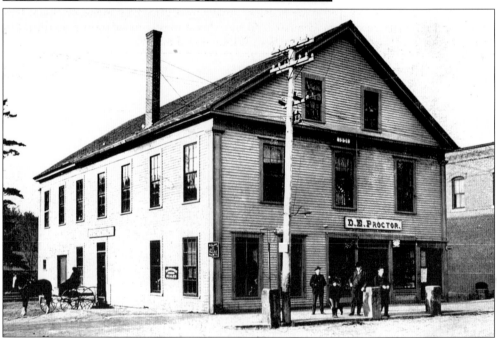

Proctor's Store, also known as the Depot Store, was built in 1851 by Joseph Newell. It survived all three of the fires that devastated Main Street between 1874 and 1885. The store operated, under varying managements until the 1930s, when it was torn down and a gas station put up in its place. At the beginning of the 20th century, it was one of the first places in the area that offered the modern wonder known as the moving picture film.

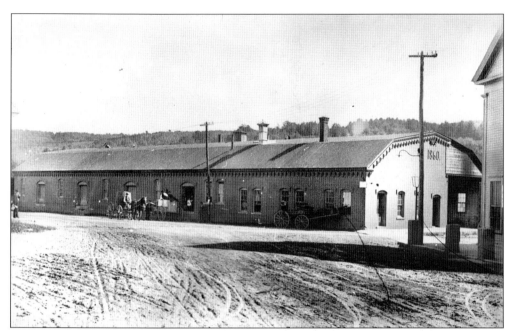

Two of Wilton's railroad stations are shown in photographs taken *c.* 1860 and 1925. The long brick building (above) was built in 1860 on the site of the first station, a small clapboarded building constructed in 1851. It was replaced by the current structure (below) in 1892, when the brick building was damaged in an accident involving a derrick on a wrecker train. Rail service to Boston and beyond was common and was a boost to year-round tourism in the town. The last vestiges of passenger rail service from Wilton ended in 1952.

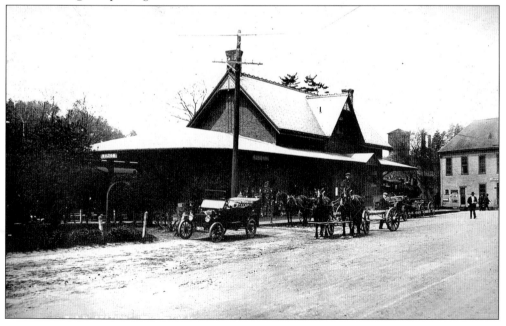

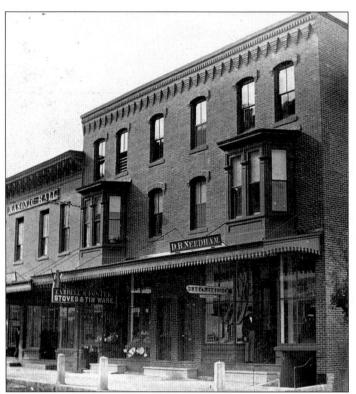

This view of Main Street includes D.B. Needham's store and the old Masonic hall. This photograph is probably from sometime between the fires of 1874 and 1881; it shows how significantly Wilton had grown by this point, to have many large buildings in a thriving downtown even in the aftermath of a major fire.

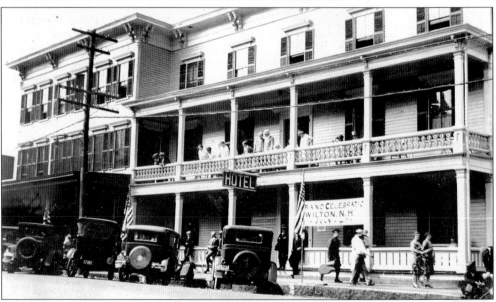

A testament to the large numbers of tourists and travelers who frequented this area in the late 1800s through the mid-1900s, this hotel is what came to be called the Everett House. Opened c. 1875, it was likely built to replace an earlier hotel on the site—the Jones Hotel, which probably burned in the fire of 1874. For some time in the early part of the 20th century, the hotel was known as the Wilton Inn. By the late 1920s, it was called the Souhegan Inn for a time. Later, it was again called the Everett House. It was demolished in 1948.

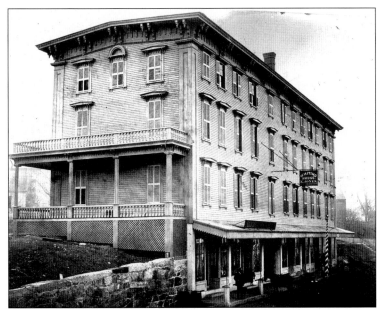

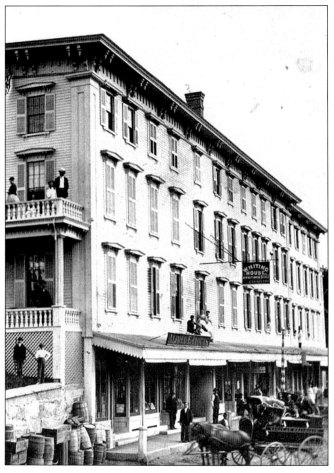

The Whiting Hotel, built in 1866 in the East Village, grew over the eight years it stood. It is pictured before 1874, when fire destroyed it and most other Main Street buildings. David Whiting was the first proprietor, followed by Dr. William A. Jones. Since the railroad line from Nashua terminated in Wilton, the hotel was a major coach stop for passengers proceeding on to Peterborough, Dublin, or Keene. Mark Twain is said to have stayed here once. The ground floor held numerous stores, including the A.E. Jaques dry goods, A.P. Fitch drugstore, S.H. Dunbar market, A.H. Smith jewelry store, Charles Tarbell Clothing and Furnishings, D.B. Needham dry goods, and Miss Hall Millinery. In 1883, the town voted to remove the seat of town governance from the center to the East Village, and the hotel site was chosen for the location of the new building.

This view shows Main Street in the wintertime *c.* 1900. Notice the wooden awning that ran almost all the way down the street, covering the sidewalk.

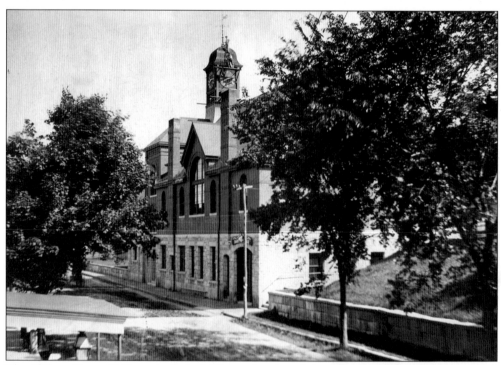

The Wilton Town Hall was built in 1885 on the site of the old Whiting Hotel. The radical changes brought by the railroads and the mills resulted in the locus of town government being moved from the old center of town down into the river valley. Note the workmen on the steeple.

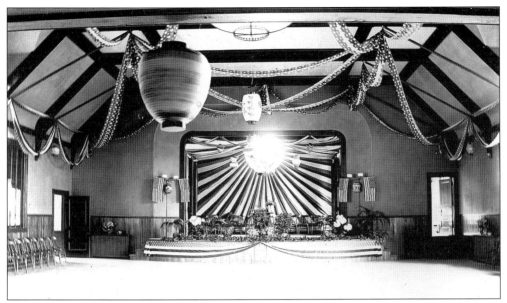

These two views of the interior of the town hall auditorium may have been taken at the dedication of the building, in January 1885. In addition to hosting town meeting, the auditorium served many functions for the town. It was a theater where live professional vaudeville and early silent films were presented. The auditorium was also the site of amateur plays, basketball games, dances with live orchestras, music concerts and recitals, and lectures. It still operates as a movie theater showing first-run films.

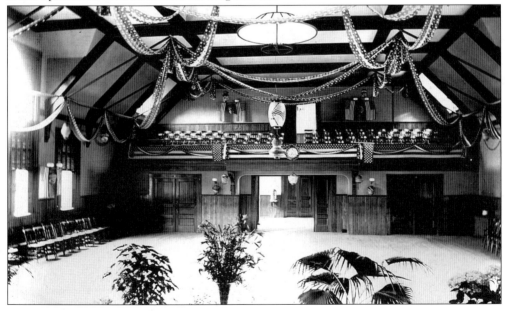

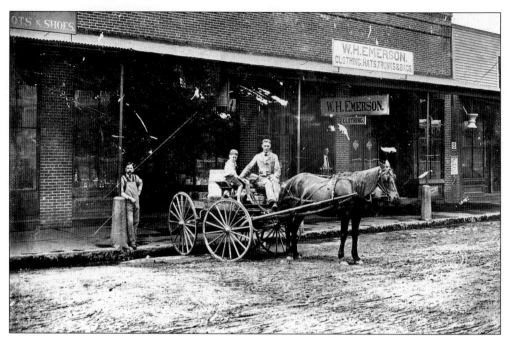

Two mainstays of Main Street business were E.A. French and D.E. Proctor. Above, in front of French's store *c.* 1910, are Edwin A. French (in the wagon) and his assistant Patsy Kennedy. The boy is probably French's son Richard. Below, inside Proctor's store in 1904, D.E. Proctor is standing in the right foreground, wearing a Panama hat. George Proctor is in the right background, and Eugene Rideout is the tall man behind the counter in the background.

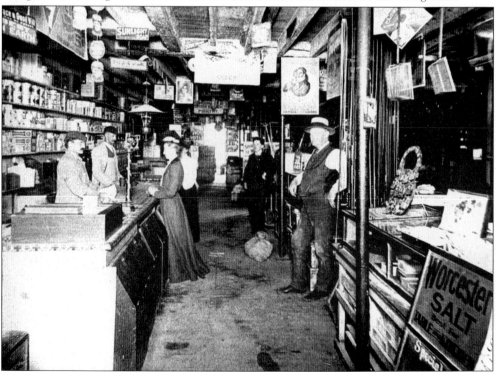

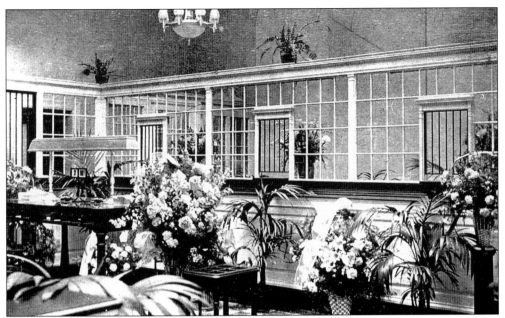

The interior of the Wilton National Bank is shown in a postcard issued to commemorate the opening of the building on May 20, 1929, just five months before the stock market crash. By all accounts, the Great Depression (while certainly no walk in the woods for the residents of Wilton) had somewhat less of an impact here than it did in other parts of the country.

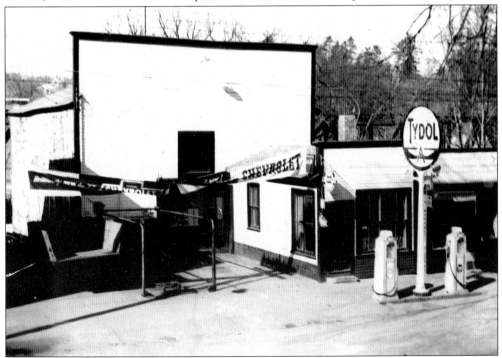

The old Draper Garage on Main Street is pictured sometime in the 1930s. It was one of several gas stations in town (note the Tydol sign), as well as the local Chevy dealership, and it remained in use until Guy Draper built a new showroom and garage in 1952.

Main Street is seen *c.* 1920 with "the Dummy," a traffic warning signal used to remind early motorists to keep to the right.

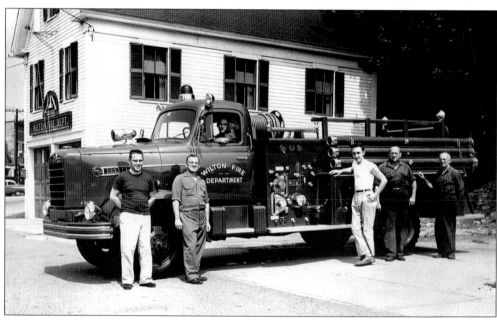

This is the old firehouse *c.* 1957, before it was torn down to make way for the new larger structure, built in 1959. Showing off the town's latest piece of fire apparatus, from left to right, are Bob Pollock, Wilfred Burbee, Ray Mahoney, Frank Edwards, and Lynn Potter. George "Guy" Draper Jr. is sitting in the truck.

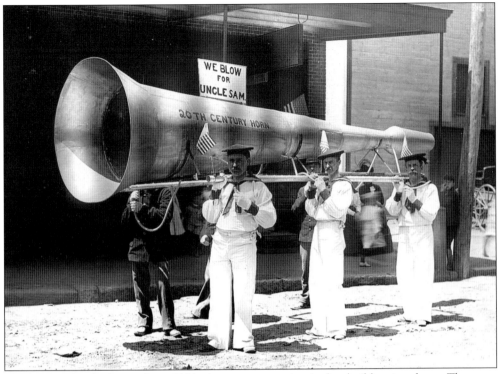

For the Fourth of July parade in 1901, these men were inspired to build a giant horn. The town often celebrated in a big way for the holiday, with musical concerts, baseball games, and the requisite fireworks displays. The men in the foreground, from left to right, are George Kilpatrick, Warren Foster, and Edwin French. Not so visible in the rear of the horn (but duly noted on the back of the photograph) are George Hutchinson, Henry Balmforth, and Jerry McCarthy.

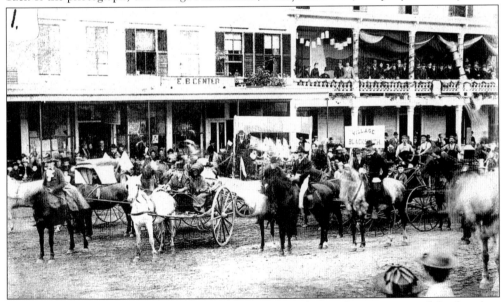

In 1889, a parade was held on Main Street to celebrate the 150th anniversary of the founding of the town. In the background are E.B. Center's store and the Everett House.

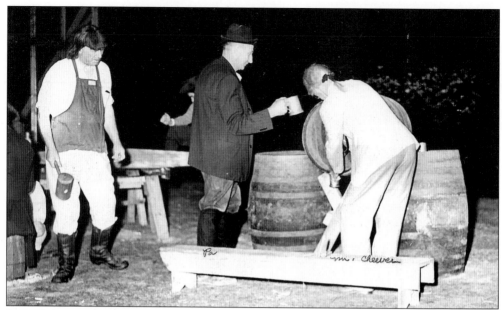

Part of the 200th-anniversary celebration of 1939 was the re-creation of the raising of the second meetinghouse on September 7, 1773, in Wilton Center. During the original construction of the building, which burned in 1859, a center post snapped and the work collapsed, killing several people. Shown from left to right are Luther Langdell, Eugene Rideout, and Harold Cheever. As far as we know, these three came through the re-creation unscathed.

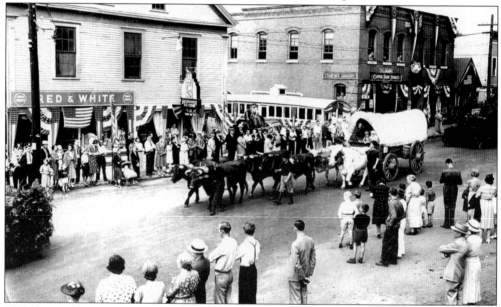

This photograph of the 1939 parade for the 200th anniversary of the founding of Wilton features a local landmark for many years: the Wells' Diner (center), later Oscar's Diner. It was located between the Stanton Block (right), where the post office now stands, and Proctor's Store (left), which has long since been torn down. The diner was moved in the 1940s across and farther east down Main Street, where it became the Wilton Diner, which operated until 1995. The building was demolished several years later to make way for the new firehouse expansion.

George May (left) and David E. Proctor, proud Grand Army of the Republic veterans, are shown in 1923. It is interesting to think that when these two were young soldiers for the Union cause, they likely knew many older residents of the town who had fought in the American Revolution. Thus it is that our history is passed down, not only in books but in the living memory of one person to another, one generation to the next.

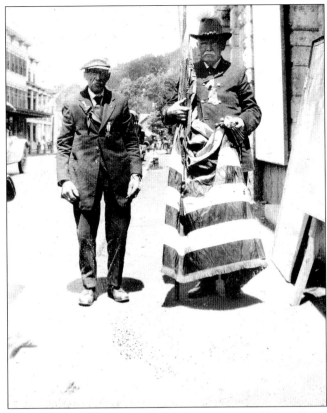

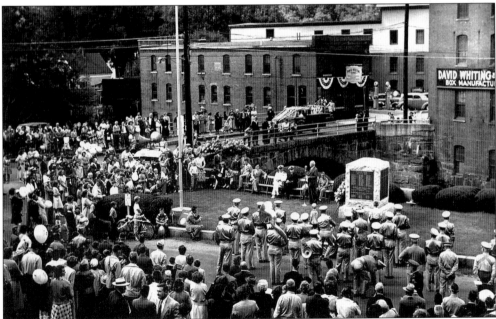

Sen. Charles Tobey stands at the microphone during the rededication of the war memorial in Wilton in 1949. Later additions to the site include memorials to the veterans of the Korean and Vietnam Wars.

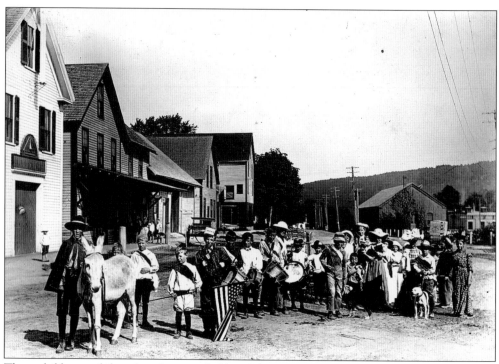

These children and their friends are probably celebrating the Fourth of July *c.* 1890–1900. They are standing almost opposite the old fire station, with the railroad freight building in background.

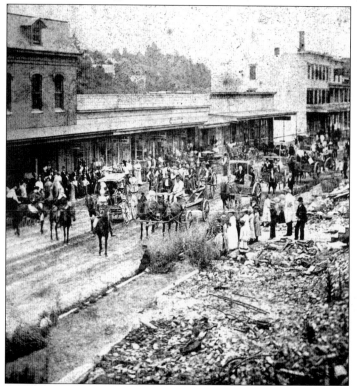

A testament to the spirit of the citizens of Wilton, this celebration on Main Street probably took place soon after the first fire in 1874. The photograph was taken from where the Whiting Hotel had stood. The town rebuilt its Main Street three times in the space of 11 years after horribly destructive fires decimated the East Village.

Two

TEMPLE

In the past, the circumstances of life in Temple produced a community
without much conscious effort on the part of its people. That day I fear has gone.
But we must not lose—we cannot realize our full humanity without—the values
that community brings. The great virtue of the American small town
in the past was the face-to-face quality of its living, and the strong personal ties
it afforded. . . . [However] we can no longer expect community in America
to develop automatically; we must seek, we must make it.
This requires invention—social invention to counterbalance those mechanical inventions
that have revolutionized our material existence. It is a task for us all, for those who
moved to town last week . . . as well as for those whose ancestors cut their way
here through forest. . . . We must emphasize the more and more we have
in common; pay less attention to the less and less that separates us.
As we look forward to Temple's next hundred years, let us determine, then, to recognize
that all who live here have a shared responsibility to preserve and strengthen that which
has been most precious in our history—close association and close cooperation,
responsible participation in the communal life, the joint creative fashioning
of a truly human—because genuinely social—existence.

—Dr. Karl Bigelow
Temple bicentennial address, 1958

Dr. Karl Bigelow's wisdom and eloquence speak to us as powerfully today as they did nearly 50 years ago. To hang on to our strength and values as a community—to keep our village "the same" and at the same time embrace forms of change that will enhance our daily lives and future prospects—is a balancing act that challenges us all.

The vital institutions that define Temple—church, school, library . . . town meeting . . . work and play—have all undergone change. Church services last an hour nowadays, not 10, and men and women sit together. No longer must the librarian's husband deliver her report to the town fathers; she delivers it herself. Erstwhile male bastions of the fire department, the Lions' Club, and the band have long welcomed women. "Town fathers" now include "mothers" as well.

Livelihoods have changed, shifting slowly from the agricultural base of Colonial days through larger, more ambitious undertakings of orchard keeping and poultry and dairy farming to today's larger proportion of professional services and cottage industries: carpentry, building, and arts

and crafts. A growing number of "dormitory people" commute to far-flung jobs.

Play also has changed over the years. Modern-day Temple boasts a playground and an active recreation commission and is part of the Little League—new wrinkles on old community-based activities. Skiing came in the 1930s, when Charlie Beebe opened the first ski area in New Hampshire at Temple Mountain. A tennis court was built in the mid-20th century. The internal combustion engine brought noisy vehicles and noisy toys—motorcycles, skimobiles, RVs, ATVs.

Education has seen changes. Of the half-dozen one-room schoolhouses existing in the 1800s, only one remains, relocated and lovingly restored by the Temple Historical Society. (The field in which it now stands, however, is as old as the village itself, grazing ground for sheep and cattle in Colonial times.) When a new consolidated schoolhouse was built in 1918, the one room became two (and later four). Today's pupils enjoy a separate room for each class, kindergarten through grade four, in a spanking new school building.

No longer, however, do the schoolchildren walk up the road every Wednesday afternoon to visit the library—too far. Other longtime town customs have died quietly. May baskets are seen no more, and the Ladies Aid no longer gathers at Christmastime to make wreaths and roping for the "greening" of town buildings.

Do such losses mean the end of community? They do not. The Ladies Aid thrives still, conducting rummage sales and other events to raise funds for community projects. The Good Roads Day of the 20th century, when able-bodied men and women teamed up to repair and improve Temple's roads, has been reborn in the form of a yearly spring cleanup. The Harvest Festival brings townsfolk together every fall in a common cause to raise money for the maintenance and beautification of the town's green areas.

Such change means evolution, not loss—healthy, inevitable growth into new times, new needs, new goals. The pictures in this chapter recall a Temple gone by, but it is a Temple that in the most vital sense is with us always.

"Let us, and those who follow, consider well our Temple heritage," concludes Dr. Bigelow. "Let us . . . enable the speaker at Temple's third centennial . . . to say, after he has described the wondrous changes that we cannot today foresee, 'But Temple is still Temple, after all.'"

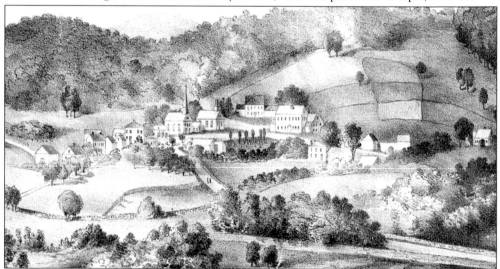

Uriah Smith was 15 when he drew this sketch, the earliest depiction of Temple village (1847). The drawing shows the town's second meetinghouse, which was completed in 1784. After the Universalist and Congregational churches erected new buildings (1841–1842), the old meetinghouse gradually fell into disrepair. Three years after Smith made his drawing, the town sold the meetinghouse for the sum of $300, and it was eventually dismantled.

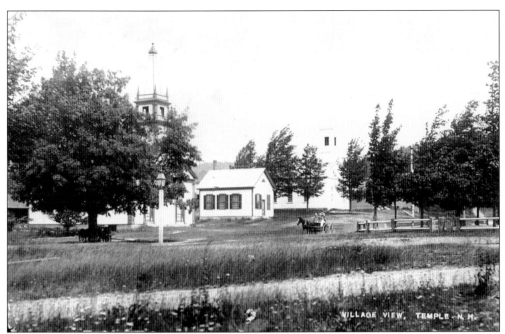

Two 1917 views of Temple show kerosene-illuminated lamp posts. In 1901, a lamp post was placed at either end of the common. A third stood in front of the general store (below). The earliest town record of a lamplighter is in 1903; the custom continued up until World War I. In 1917, Temple's store and livery stable were leased and run by William Sheldon and Charles Holt. Henry and Walter Hayward's earlier store burned in July 1882, but it was quickly rebuilt and opened on Thanksgiving Day.

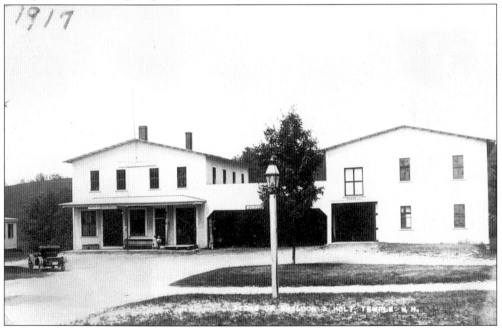

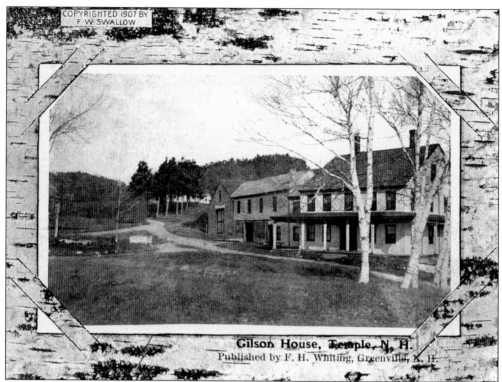

Gilson House, Temple, N. H.
Published by F. H. Whiting, Greenville, N. H.

The old tavern looked different when Thoreau dropped by in 1852, 40 years before Daniel and Maria Gilson undertook massive renovations and reopened for business at $6 to $10 per week, room and board. In the 1880s, the tavern doubled as post office and general store. Today's Birchwood Inn, its bricks (made in Temple) long since repainted their original red, offers "casually elegant dining."

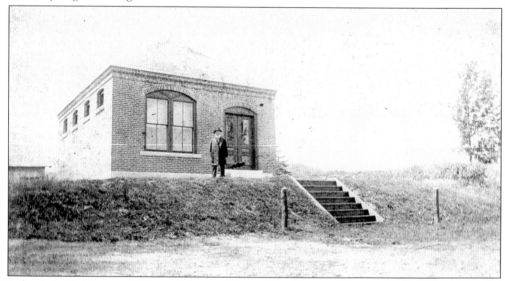

Solon Mansfield poses in front of the new library, his Christmas present to Temple in 1890—less than eight months after the town voted to accept his gift of $1,000 for the little brick building. Additions in 1951 and 2002 altered the library's roofline.

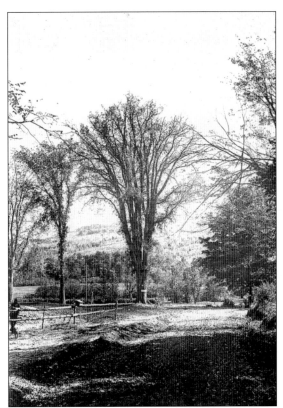

The stately elm, which once adorned towns all over New England, succumbed to Dutch elm disease in the mid-20th century. Temple's last standing elm was cut down in the late 1970s. The village view below shows some of the extensive apple orchards that flourished in Temple in the 1930s and 1940s. Old orchards remain scattered on the east and north sides of town, but their heyday is over.

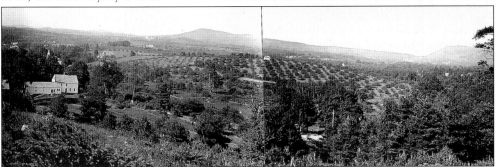

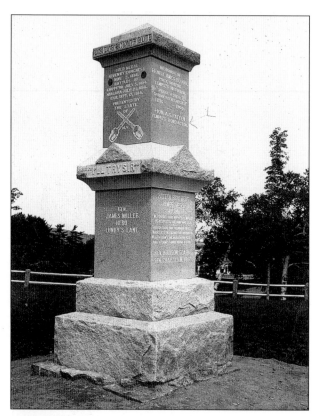

Located at the north end of the common, this monument honors seven soldiers of the War of 1812—notably Gen. James Miller, who acquitted himself with such valor during the invasion of Canada that he was acclaimed a national hero.

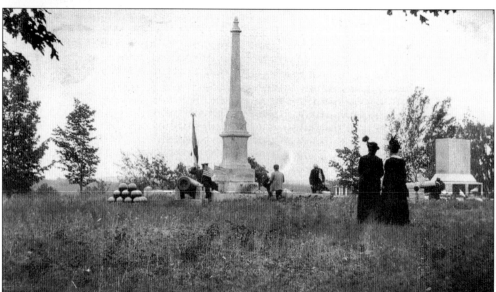

Many in this early-1900s picture would have known the six men to whom the Soldiers Monument is dedicated: "Our Soldiers who fell in the War of the Rebellion." Aged 19 to 67, they died far from home at Bull Run, Chattanooga, and Camp Nelson, Kentucky. Designed by H. Brennan of Peterborough, the heavy marble monument was hauled over Temple Mountain in a cart drawn by four oxen.

The monument on the south end of the common honors 53 Revolutionary soldiers and pioneers. This monument and its counterpart at the north end of the common were dedicated on Old Home Day, August 21, 1901. The stones at the base, representing the 13 original colonies, were presented at Temple's sesquicentennial celebration in 1908.

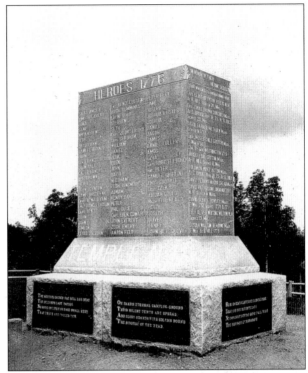

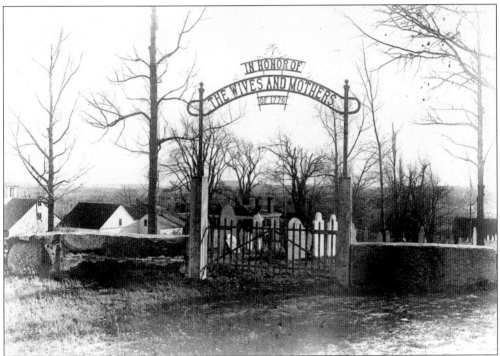

The iron gate leading into the Old Burying Ground, Temple's earliest cemetery, is dedicated to the wives and mothers of 1776—an inscription believed to be unique in New England. The gate was dedicated on Old Home Day in 1901, along with the monuments.

Apple blossoms frame one of Temple's handsome old stone bridges. (Photograph by Bernice Perry, courtesy Peterborough Chamber of Commerce.)

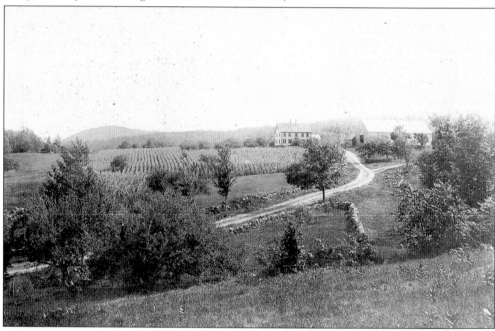

Another mid-20th-century agricultural enterprise was the raising of corn, both for the table and as fodder. As dairy farming dwindled, so did the need for feed corn. Villagers now raise their own sweet corn or buy it at local farm stands. This fine panorama of cornfields marks an era gone by.

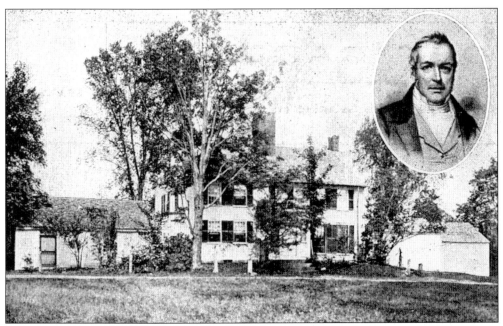

A commemorative postcard shows the home of Gen. James Miller, the renowned 1812 war hero, and an inset portrait of the general himself. The house is one of the earliest in Temple. Built in 1786, it served in the 18th century as a general store. Note the elms, now long vanished.

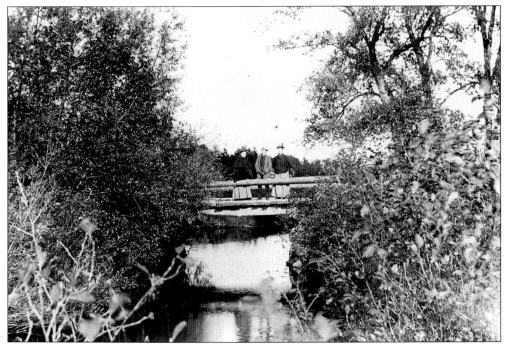

A trio of Sunday strollers pauses on a bridge over Miller Brook across General Miller Highway from the home of "the hero of Lundy's Lane."

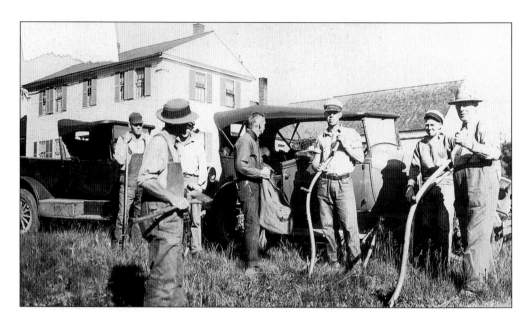

Good Roads Day crews set to work in 1920 (above) and 1948. In the lower picture, Sen. Charles Tobey (third from right), an enthusiastic booster, leans on his rake to contemplate the labor ahead. In earlier days, able-bodied men and boys assembled after mud season to level roads, fill in gullies, and generally repair the ravages of winter. The town acquired road tractors and graders in the 1920s, and a paid road agent and his men took on the heaviest work. However, Good Roads Day was still a necessity and a community tradition. (Photograph by Bernice Perry, courtesy Peterborough Chamber of Commerce.)

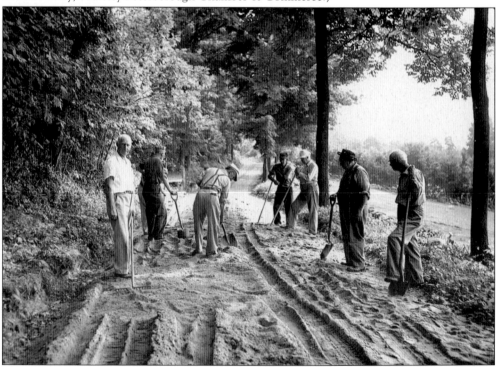

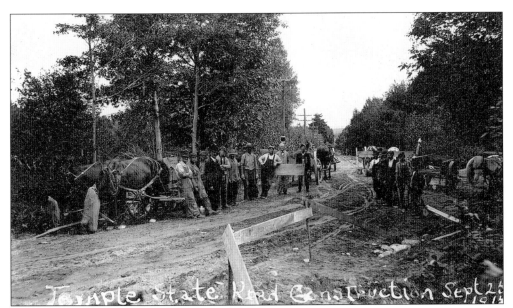

Temple men and boys turned out for other, bigger projects than repairing local roads. Here, work progresses on the new east–west Route 101 through Temple in September 1915.

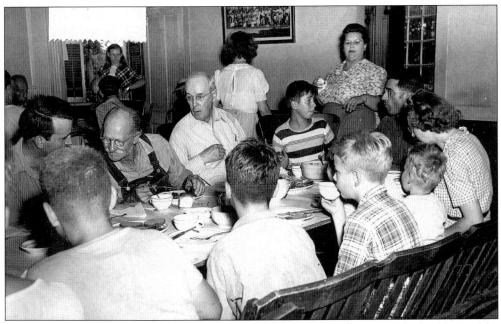

A hardworking crew chows down at the 1948 Good Roads Day dinner, cooked and served by women of the Temple Grange.

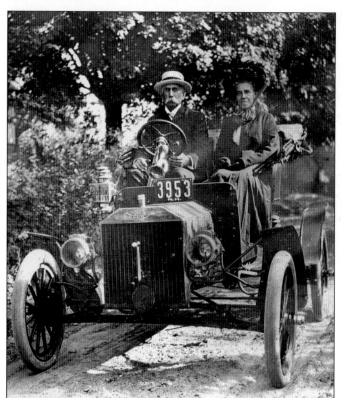

Jacob Kendall takes his wife for a spin in their dashing new automobile (1906), the first owned by a Temple family. A forward-looking farmer, Kendall was one of the first in town to own a cream separator, a hay loader, and a gas-powered circular saw. In 1915, Kendall acquired electricity in his house, run by a gas-powered generating plant.

Route 45 and Hadley Highway meet at "the Parting of the Ways" in Temple village. The upper road leads to the 1918 consolidated school and to School House No. 1, expanded into a private dwelling. En route, the road passes 19th-century School House No. 6, on its 21st-century pastoral site.

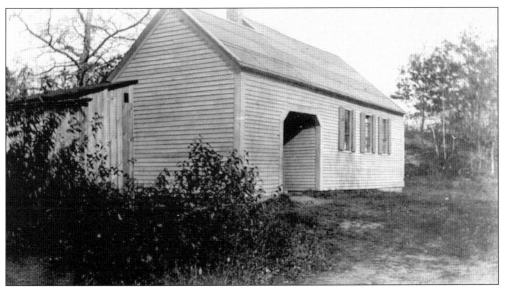

School House No. 6, Temple's last remaining one-room schoolhouse, served youngsters in North Temple. Built c. 1820, it functioned as a school until 1899, when (with only 12 pupils) it closed. The Seventh-Day Adventists used the building for a time. In 1930, Dan Barry bought it for an apple-packing shed. In 2001, the Temple Historical Society moved the neglected old school to a pasture near the village center.

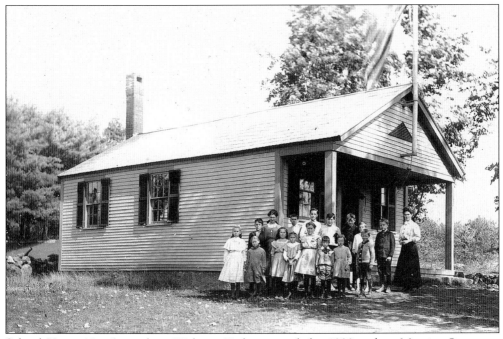

School House No. 5 stood on Webster Highway until the 1930s, when Maurice Stone, an expert in historic restoration of houses, moved it to Hill Road and rebuilt it as a residence. Of Temple's six original schoolhouses, four are private homes today.

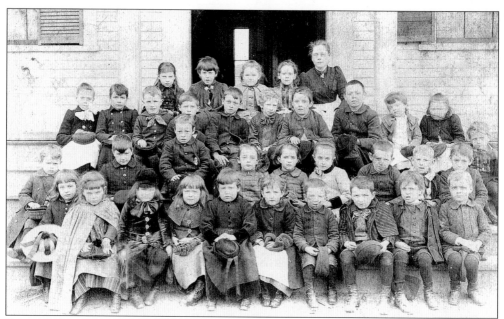

Schoolchildren (above) assemble outside School House No. 1, just south of the village. The photograph is undated, but the clothes suggest the late 19th century. A generation later (below) the shutters had been removed. Built in 1805, the school (below) stayed in operation until 1918, when the new consolidated school put an end to the one-room schoolhouse. Today, it is a private residence.

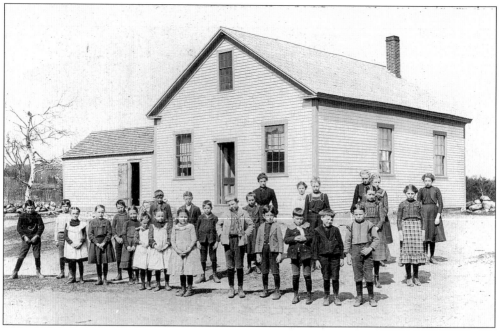

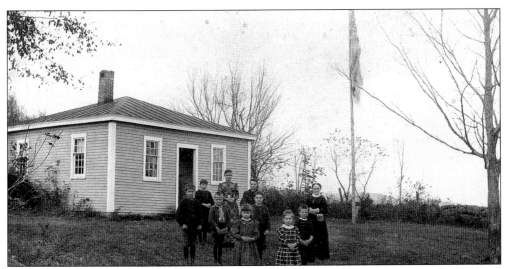

School House No. 4, which stood off Kendall Road, was built in 1855. In 1930, the structure was moved and added to the Temple Cabins.

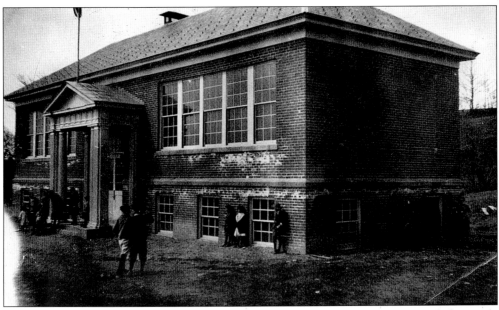

With the erection in 1918 of a consolidated school, all Temple children attended a single school. Under the cooperative school plan, students gradually transferred to Peterborough until the Temple School housed only grades one through four. In 1998, a new school was built a mile from the village center.

In 1914, six Temple mothers bore seven babies. Here they all are, except Mother Jowder, who was probably taking the picture.

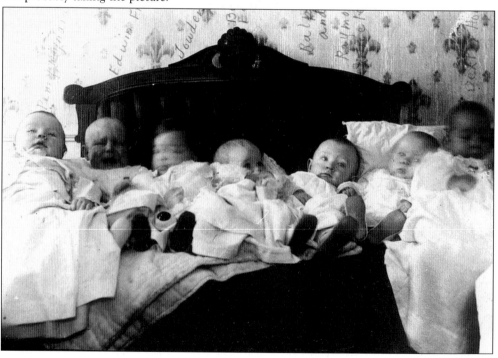

Three Temple women don heritage gowns to participate in the town's 1958 bicentennial festivities. The gowns were then a century old.

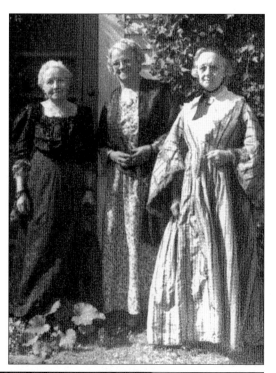

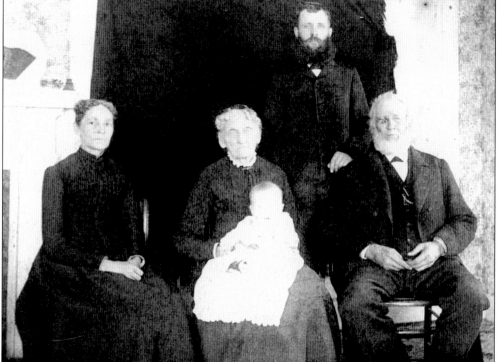

In this four-generation portrait, Solon Mansfield, the founder and benefactor of Temple's public library, poses proudly with his wife (left), his mother (center), his son (standing), and his infant grandchild.

In 1903, Charles W. Tobey bought the old Felt homestead. His wife, Francelia, bore him a son that year: Russell Benjamin, shown here dining al fresco. When Tobey died in 1953, he had served his town, his state, and his country as a selectman, state legislator, governor, and U.S. senator.

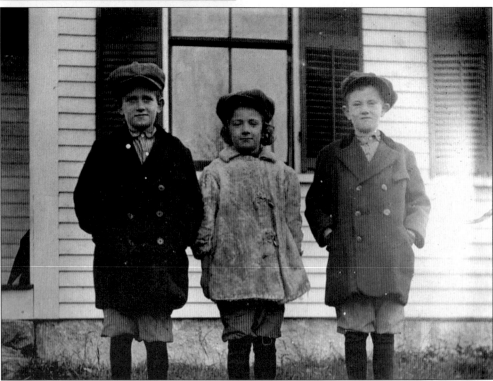

Three brothers line up for a photograph c. 1915. Herbert Willard (left), who grew up to be a poultry farmer, served as town clerk for nearly 20 years and twice as selectman. Raymon Willard (center) served as town treasurer and drove the school bus for years. Mervin Willard ran the general store for nearly four decades, doubling as postmaster.

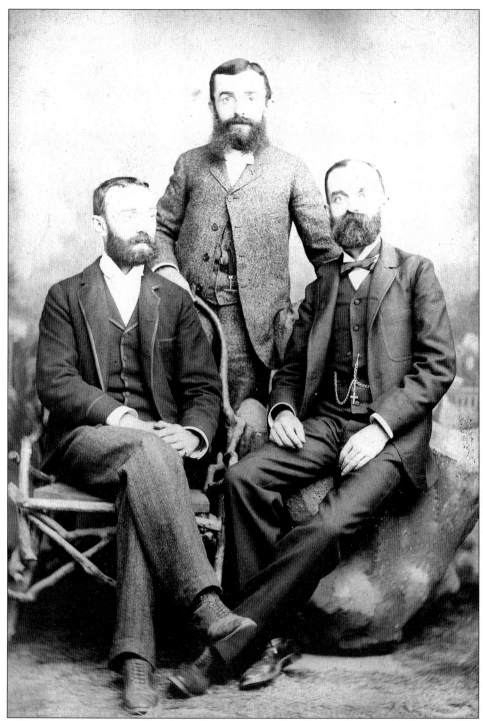

Another trio, from left to right, shows Charles, Joseph, and William Bancroft Hill, three of five accomplished brothers. Charles Hill practiced law until 1909, when he retired to Temple. Joseph Hill, an instructor at Harvard, played an active role in Temple's Congregational church. William Hill, a substantial benefactor for the church, was a noted theologian.

This cheerful mother is Mary Tuttle, shown with her children, Jesse, Bertha, Bob, and baby Ed. Until 1923, the family lived at the present-day Ulch house, built by Mary Tuttle's husband and his father.

This c. 1896 photograph shows an arch and oven at the New England Glassworks. Fires and lack of funds brought about the abandonment of the ill-fated manufactory, which operated from 1780 to 1782. At that time, it was the sole glassmaking enterprise in New England. Few pieces survive; the Temple Historical Society owns a bottle in near perfect condition. In the 1970s, Boston University conducted an archaeological dig at the site.

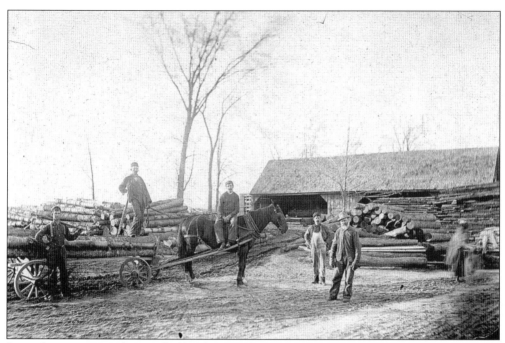

Several water-powered sawmills like the one above operated in Temple in the 19th and early 20th centuries. The picture below shows Charles Colburn's steam-powered sawmill, which operated in 1897. The last mill in Temple was the Colburns' cider mill, built *c.* 1800. Buffeted by two hurricanes, it became so unsafe by the 1970s that it was dismantled. (Below, courtesy Priscilla Weston.)

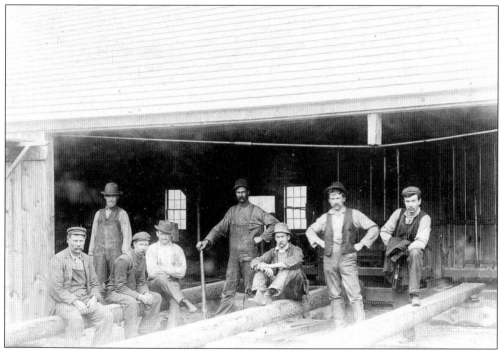

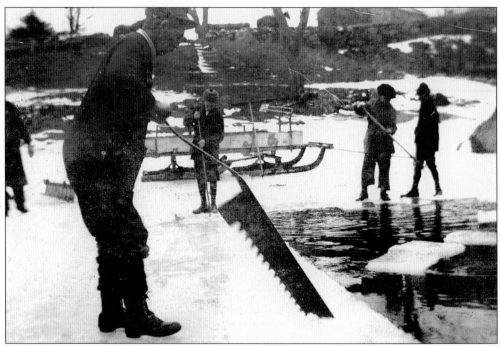

Ice cutting was a profitable business for many New England towns up until World War II, when modern refrigerators replaced iceboxes. Huge blocks of ice, covered in sawdust, were stored in icehouses and delivered to local homes during the summer to keep iceboxes cool. In Temple, ice cutting was always a local service, with handy bodies of water such as Caswell's Pond, shown here *c.* 1940, providing the town ice supply.

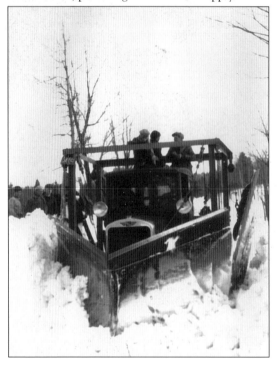

With the advent of the automobile, it became necessary to plow the town's roads. Shown here is a typical snowplow of the 1940s. Temple's was made of wood.

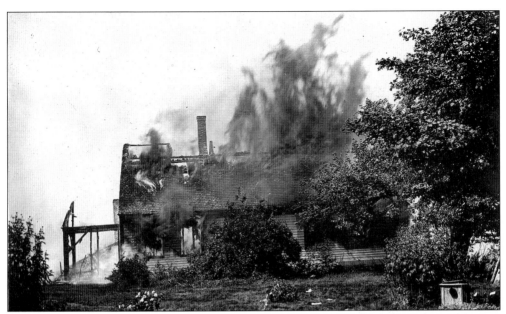

Temple's first fire truck, "Annabelle" (shown below at the 1958 bicentennial parade), now enjoys a comfortable retirement at the firehouse. Built in 1933 and purchased in 1948, "Annabelle" was a generation too late to save Jacob Kendall's barn (above), which was struck by lightning in July 1916. Both it and the adjoining house burned to the ground.

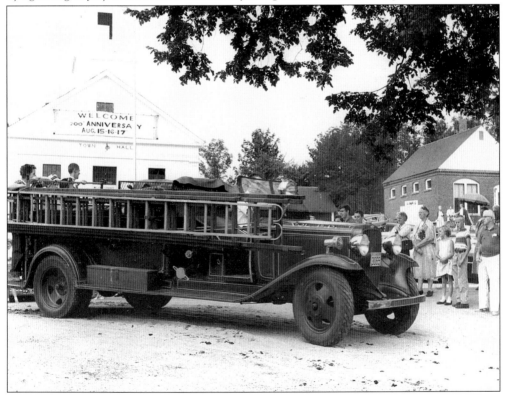

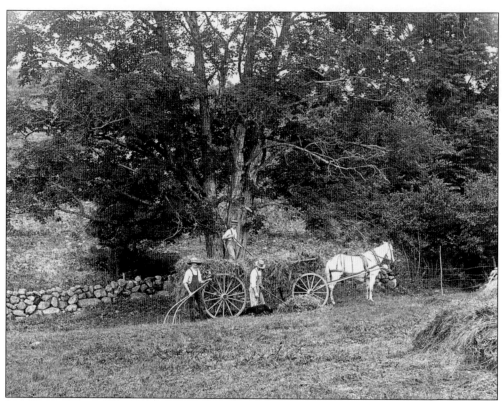

The farmers shown above are building a load of hay and raking the scatterings with a large wooden bull rake. Below, an earlier haying scene on the Tobey farm illustrates the common use of oxen to pull a two-wheeled cart.

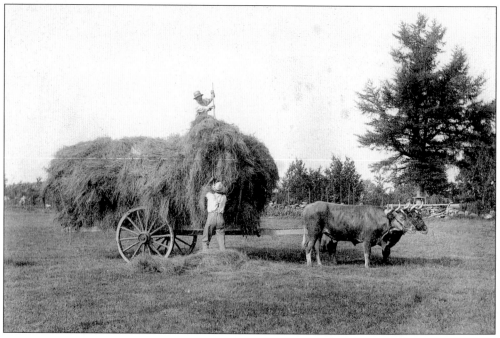

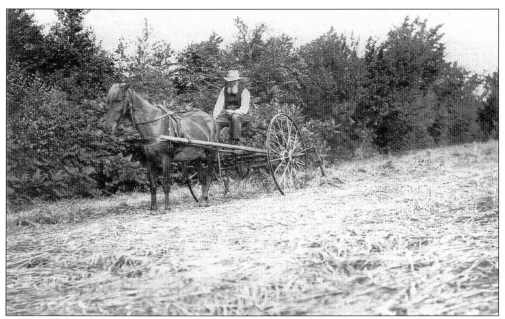

Horace Fish operates a horse-drawn hay tedder to shake moisture from the hay.

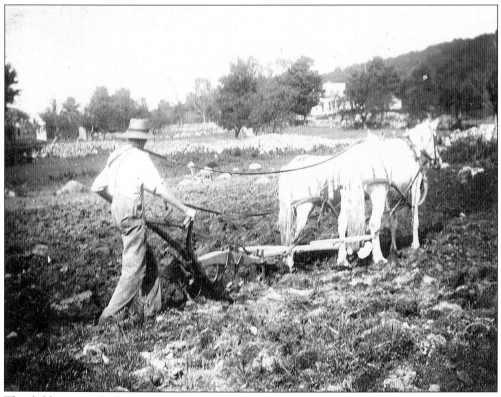

This field, next to Colburn Road, is being plowed in the early 1900s. (Courtesy Priscilla Weston.)

Abbie Kendall and her parents pose with one of their animals in the 1930s.

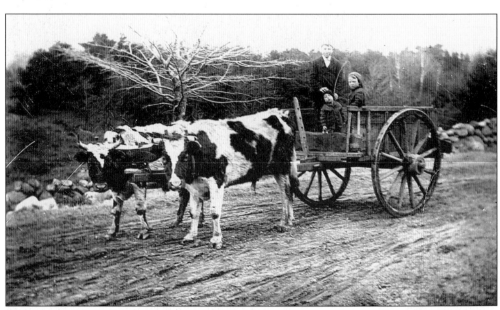

This photograph, titled "Down on the Farm," shows an oxcart and oxen. Oxen were in common use as draft animals in the early 1900s, when this picture was taken. (Courtesy Ruth Quinn.)

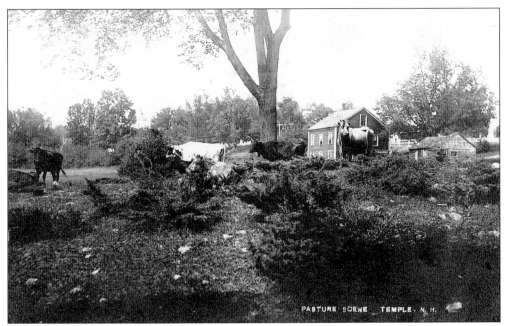

Cows on the Holt Farm find the grass greener behind the neighboring blacksmith shop.

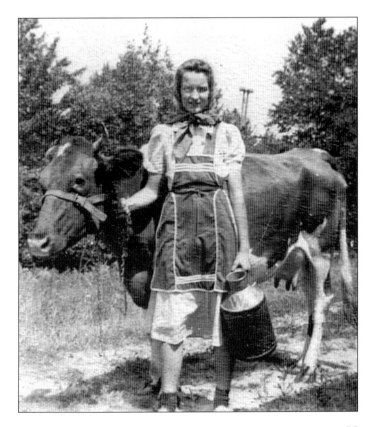

A milkmaid poses with
her cow and her milk jug.
(Courtesy Ruth Quinn.)

Shortly after World War I, Walter A. Conant developed a strain of alfalfa hardy enough for the New England climate. Conant was an inventor, not a farmer.

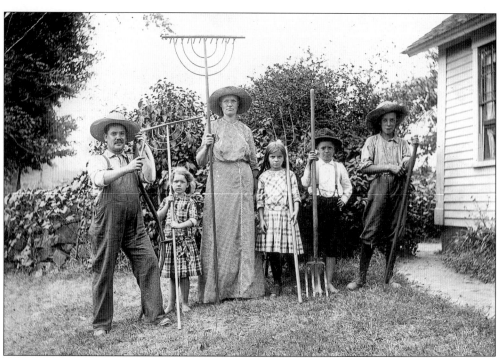

Members of the Hedman family display their haying and gardening tools.

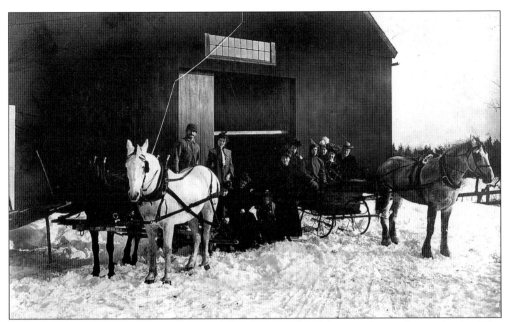

Charles Tobey is one of a group (above) heading out for a drive in horse-drawn sleighs. The family sleigh (below) stands ready in front of the Parlin-Pierce house. (Above, courtesy Priscilla Weston.)

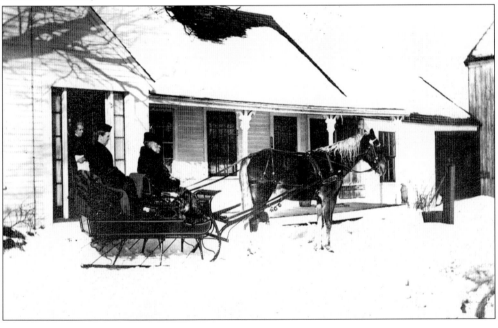

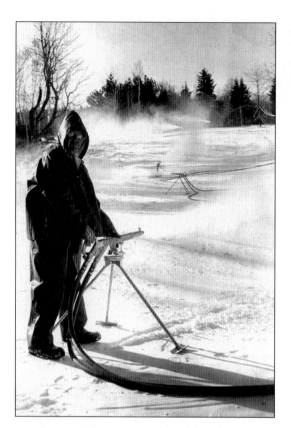

Charles Beebe, owner-operator of
Temple Mountain Ski Area,
demonstrates the state's first snowblower.
(Courtesy Peterborough Transcript.)

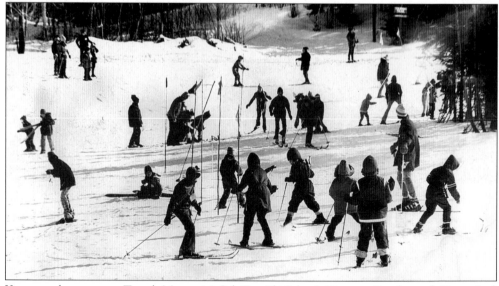

Youngsters keep warm at Temple Mountain's Sub-Zero Ski School. (Courtesy Peterborough Transcript.)

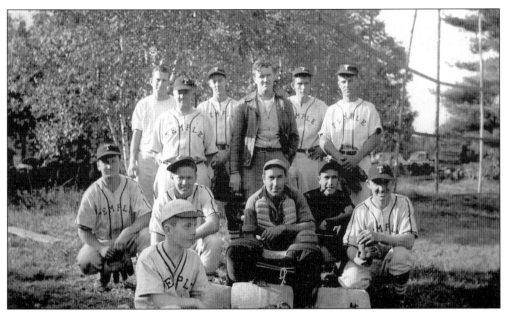

In the good old summertime, ball fields and swimming holes were essential. The town baseball team (above) poses in 1948. Caswell's Pond (below) was the village swimming hole from 1907 until the 1940s. It was also Temple's source for ice. No youngster shirked the chore of making ice cream, especially when licking the dasher was the reward.

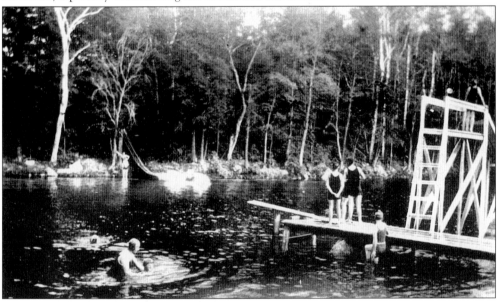

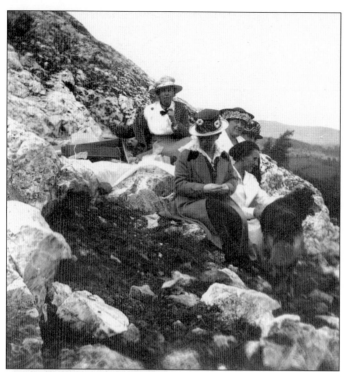

Five women enjoy the view from the White Ledges in 1921. Abbie Kendall Fish (bareheaded) gave the area to Temple's Conservation Commission. A trail is kept open for hikers and picnickers.

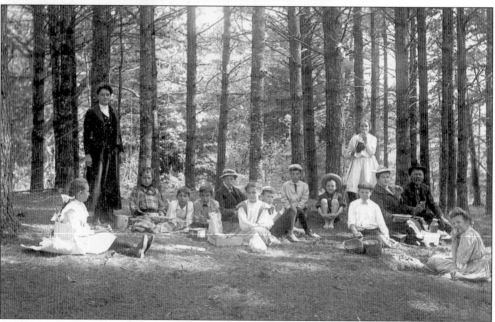

People flocked to Pack Monadnock Lithia Springs, which operated from 1891 until 1911, to enjoy picnics and slides and teeters free of charge and to take the therapeutic waters. "Contains more Lithium than any other Lithia Spring known," claimed proprietor Sydney Scammon. "Best Remedy for Kidney Trouble and Indigestion." The popular (and profitable) enterprise went out of business abruptly when Scammon was observed adding bottled lithium to the "natural" spring water.

Rodney Killam, Sydney Scammon's uncle, was a partner in the Lithia Springs enterprise. Ordered to leave New Hampshire and not come back, the two men sold the property to a lumber company and left town in a hurry.

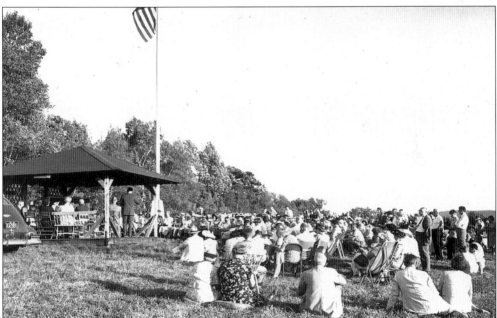

Sunset song services at the Felt-Tobey farm began in 1909 and continued until World War II. After the war, they resumed until the 1950s. This photograph was taken in 1948. Hundreds and sometimes thousands of people came to the meadow to sing hymns and popular songs, led by Charles Tobey at the piano. (Photograph by Bernice Perry, courtesy Peterborough Chamber of Commerce.)

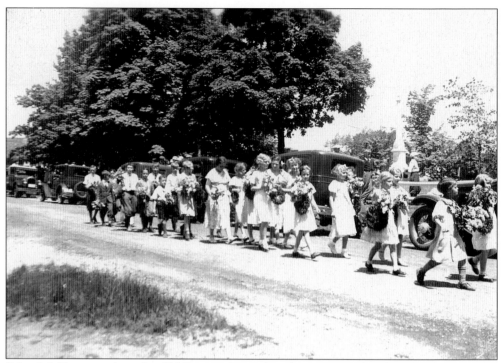

Schoolchildren march to the Old Burying Ground in the 1930s to place bunches of flowers on veterans' graves as part of the Memorial Day ceremonies.

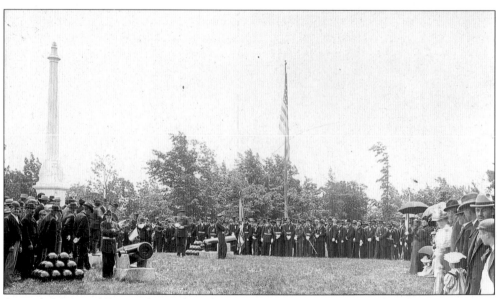

An early Memorial Day is observed on the common.

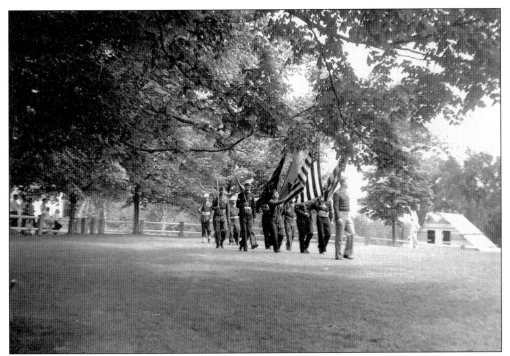

A firehouse (right) was just being built on the common when this Memorial Day parade took place in 1949. Some 30 years later, the firehouse was moved down the road a half-mile from the village to form part of a new combined firehouse and municipal building.

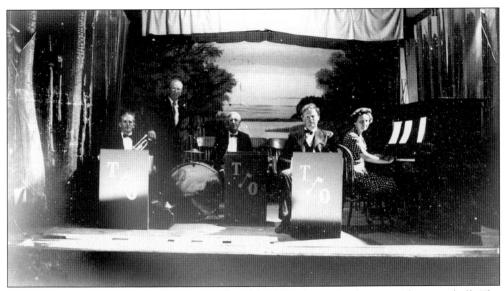

The Temple Orchestra, formed in 1938, played for Saturday night dances at the town hall. The group, which also played in Jaffrey, provided wonderful social gatherings for nearly two decades before disbanding in the 1950s.

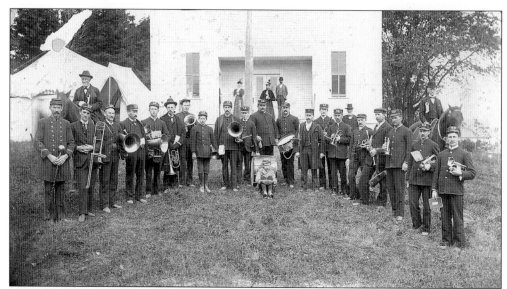

Members of the Temple Band, known as "America's first town band," pose in the 1890s in Rindge (above) and in front of the Mansfield Public Library in the 1930s. A town band was first formed in 1799. It played at the town's centennial celebration and during the Civil War and then dropped from sight. After a renaissance in the 1930s and again in the 1970s, it began playing in all parts of New Hampshire. In 1976, the band was chosen to represent the state in the national Fourth of July bicentennial parade in Washington, D.C.

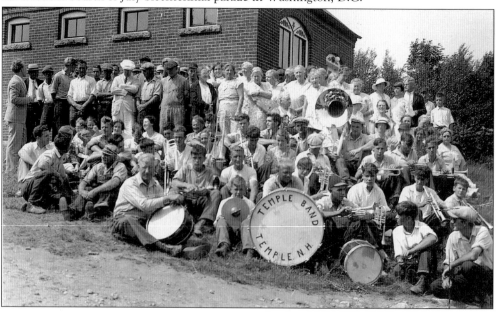

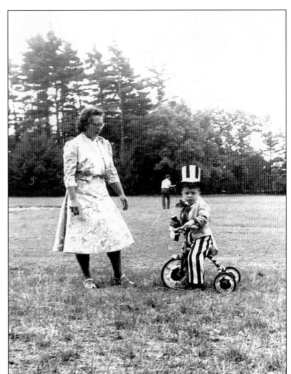

A miniature Uncle Sam (Brian Kullgren) "marches" in the Fourth of July children's parade at Temple's ball field *c.* 1954. With him is his mother, Myrtie Kullgren. The picture below shows a live creche on the common during the same era.

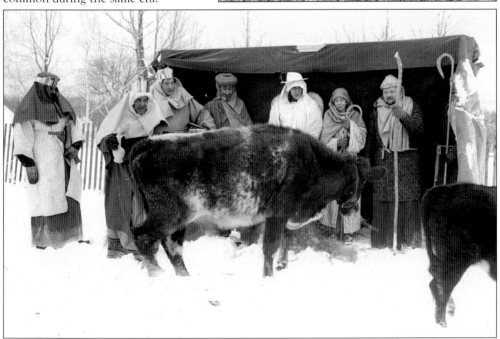

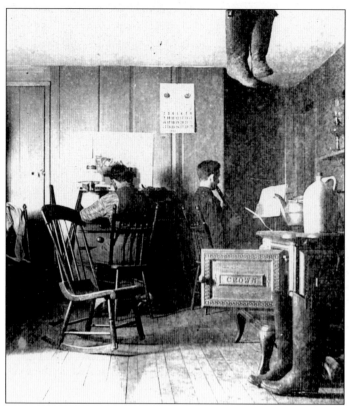

In a rare interior view of a farmhouse kitchen in the late 1880s, Will Colburn, playing the clarinet, and his brother Charles relax below a pair of boots dangling from a large hook on the ceiling. (Courtesy Priscilla Weston.)

Daniel Pratt's life exemplifies the Horatio Alger legend. Born in 1799 on the small farm shown here, he left at age 20 to seek his fortune—and found it. A builder by trade, he switched to invention, creating an improved cotton gin that set him on the road to riches. He became one of the country's greatest industrialists. His philanthropy reached Temple with gifts to church and town.

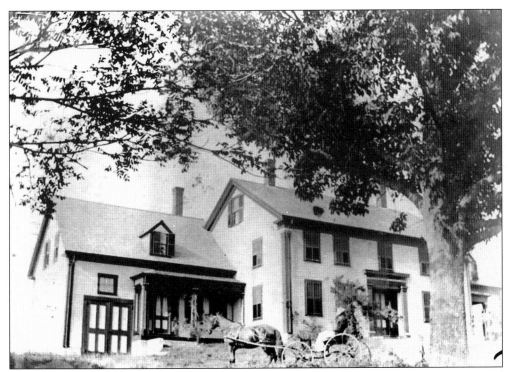

Archelaus Cummings first settled this property on East Road. The ell was moved up the road in 1968 and made into another house.

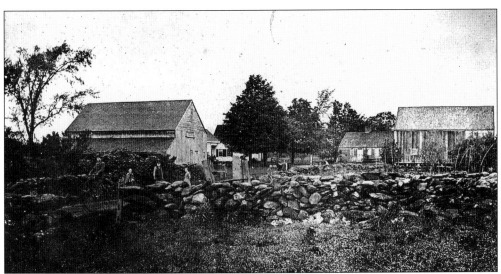

This picture shows the Wheeler Farm *c*. 1870. The older house on the right belonged to Nathan Wheeler, and the one on the left belonged to his son. Walter Wheeler is riding the old bicycle.

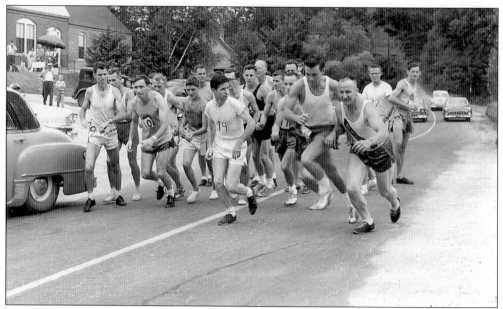

"Sleepy" Edwards takes the lead in a footrace during the 1958 bicentennial celebrations. (Photograph by Bernice Perry, courtesy Peterborough Chamber of Commerce.)

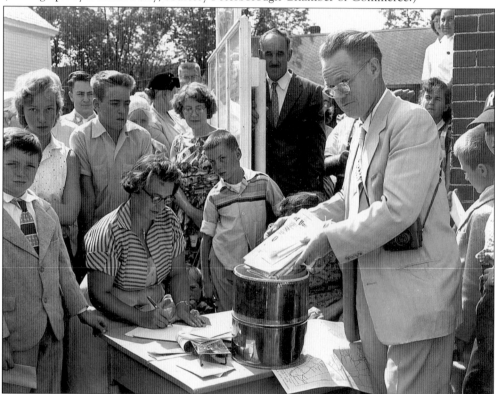

At the climax of Temple's bicentennial celebrations (1958), Carl Hedman places letters and other documents in a time capsule for burial in front of the library as part of Temple's bicentennial observance. The capsule is to be dug up in 2008. (Photograph courtesy Peterborough Transcript.)

Three

LYNDEBOROUGH

*But every morning's sun, as it climbs up these hills, makes Lyndeborough as new
as it was in the past, when our boyhood feet trod these hills.*
—Henry M. Woodward
The town's 150th anniversary, 1889

Named for Benjamin Lynde Jr., a prominent judge from Salem, Massachusetts, Lyndeborough
began as Salem-Canada, granted by the commonwealth of Massachusetts to a group of Salem
residents in 1735. After the boundary between New Hampshire and Massachusetts was
established, the town was chartered by the Masonian Proprietors as Lyndeborough in 1753. It
was chartered as the town of Lyndeborough in 1764 by the province of New Hampshire.

Lyndeborough has always been a rural community. Lacking dependable water power, the
town was unable to support large mills. The notable exception to that was the Lyndeborough
Glass Factory. Between 1868 and 1888, the factory produced some of New England's finest
glass—pieces that are now highly prized by collectors. Unable to produce the truly clear glass
made in upstate New York, the factory never made money and was closed.

The mountains that divide the town geographically give the town its main scenic character.
However, until the era of consolidated schools and tarred roads, the mountains served to keep
the area socially divided. They also provided one of the town's major agricultural products in
the first half of the 1900s: wild blueberries. The abundant fruit covered the wide-open
mountaintops and was shipped by the hundreds of crates to Boston markets. Picking blueberries
is still a popular summer pastime.

Apples were another main export, with the town's many south- and east-facing slopes
covered with orchards that at one time drew tours of blossom viewers and later those who
wished to pick their own apples. Many of those orchards still exist but have mainly closed,
victims of the changing markets.

Milk was also shipped to the city markets by train.

Two engineering feats made the town what it is today: the building of the Forest Road in the
1830s and the coming of the railroad in 1873. The road moved the commercial center of the
town from Lyndeborough Center to South Lyndeborough, and the railroad completed the
change, reducing the Center Village to the town hall and Congregational church as it is today.

The building of the railroad from Wilton to Greenfield entailed two engineering marvels: a
long wooden trestle leading across the flats into South Lyndeborough from the southeast and

the Gulf Trestle, some 200 feet long and 70 feet above Stoney Brook. The wooden trestle is gone, filled with gravel, but the Gulf Bridge is still in use in its third form.

In addition to collectible glass and some spectacular scenery, including Purgatory Falls, the town also claims the Lafayette Artillery Company, the second oldest independent company in the country. Dating from 1804 as a state militia, the company later became part of the National Guard and served in the Civil War. It was mustered out in 1882 and became an independent company. Still possessing its last field piece, an 1844 brass six-pounder, the company takes part in many civil celebrations and continues to celebrate George Washington's birthday with an annual ball.

Purgatory Falls, located on Black Brook and the Mont Vernon border, was once the site of an annual celebration based in Mont Vernon. It is now included in a conservation area and is a popular hiking destination. The area includes several glacial potholes, a stone profile, and spectacular cliffs.

The commercial farms are gone, but the town remains rural, with some winding dirt roads, wonderful stone walls, and great scenery.

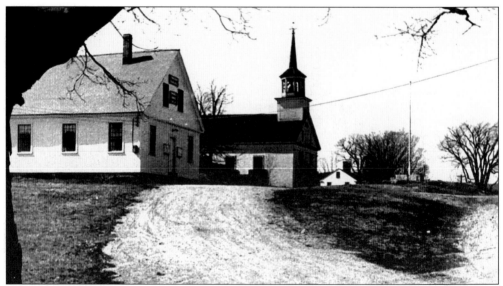

The town hall, the former Congregational church, and the town pound (between the town hall and the church) are listed on the National Register of Historic Places. The three structures constitute Lyndeborough's historic district. Several attempts have been made to enlarge the area to include surrounding historic homes.

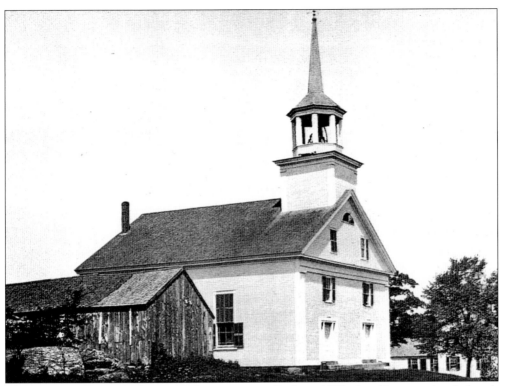

The Center Village was the original town center. Built in 1837, this Congregational church building replaced the earlier meetinghouse. The horse sheds on the left were completed the next year and were removed in the 1930s. Renovations were made in 1886. The supporting timbers of the steeple were replaced in 1986.

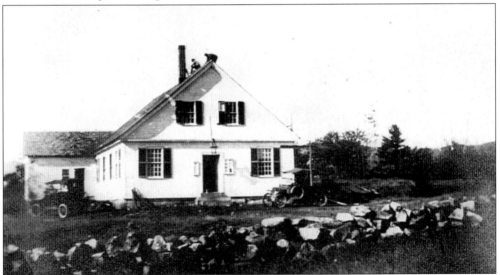

After the old meetinghouse was taken down in 1843, residents spent a couple of years trying to decide what kind of town hall was needed and where it should be built. This building was decided upon in 1845 and was the site of town meetings until the 1960s. It also housed Pinnacle Grange No. 18 for many years.

Melchizadeck Boffee built a house here off Center Road c. 1770. The house was later owned by his son John Boffee and, still later, by James, David, and Arthur Grant. Owned by Howell Wilcox when it burned, it was replaced by the present house.

This home in Lyndeborough Center was built for Dr. William A. Jones in the mid-1800s. Residents wanted a doctor to live in town, and there was no suitable place. So, they built a home. The barn was the first in town raised without rum for the workers. Later owners included Belle Boutwell and Kenneth and Margaret Mills.

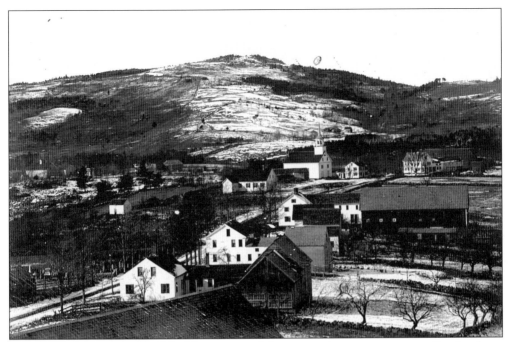

Lyndeborough Center in 1905 had few trees, and the mountain was open pasture, first for sheep and later for blueberries. The picture was taken from Boutwell's windmill, which no longer exists. Also gone are the house in foreground and the fourth house toward the church.

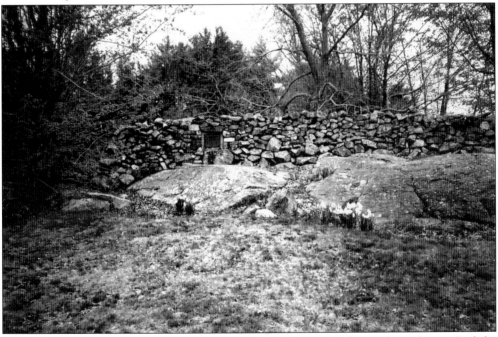

In 1774, the town voted to build an enclosure to hold livestock taken in lieu of taxes. Built by George Gould and Thomas Boffee, the town pound is 25 by 35 feet, with 6-foot walls. It was once capped with a timber frame and equipped with gate and lock, but only the stonework remains today.

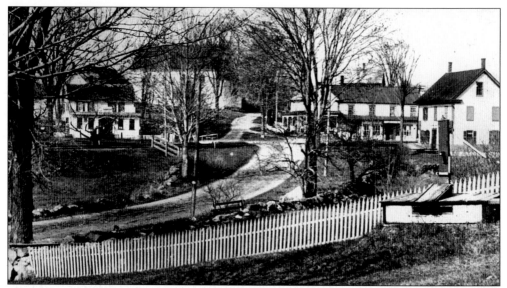

South Lyndeborough has changed since this picture was taken c. 1910. The center of the picture is now the common. The building on the left was then a variety store, and the house on the right, now the United Church parish house, was the railroad station. The porch is gone from the village store.

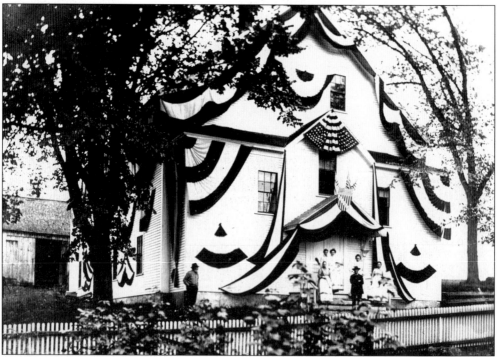

Citizens' Hall was built in 1888 as a social center for the Lafayette Artillery Company. In 1904, the company celebrated its 100th anniversary, which accounts for the above decorations. Politically controversial, the building was the subject of lawsuits, town meetings, and citizens' petitions. It was renovated in 1999 by volunteer labor and was placed on the National Register of Historic Places in 2000.

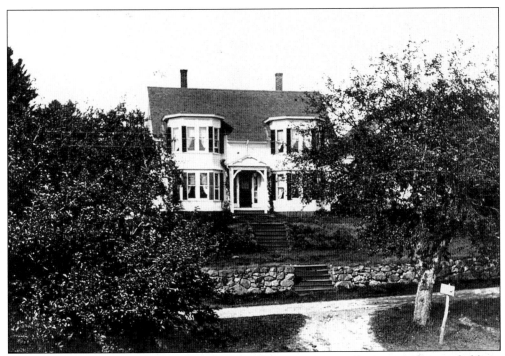

This house on School Street was built by John Emery, a music and voice teacher, probably in the 1880s. The bay windows were added c. 1900. The house was later owned by John Emery's son Harlan and then by his son-in-law Wells D. Foote Sr., whose descendants still own it.

This house on School Street was built by John Fletcher Holt in the mid-1800s. It was later occupied by his granddaughter Flora Holt and then by Fanny Putnam, who owned it in 1905. It was later the home of Richard Cheever and family.

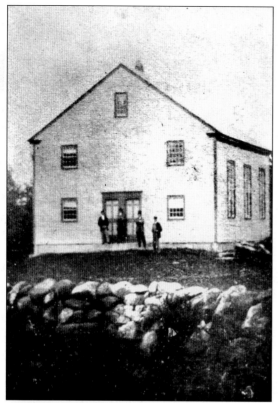

The Lyndeborough Baptist Church was formed in 1829. A lot was donated by Ephraim Putnam, and this plain, stark building, without steeple, was erected and dedicated in 1836. It was located where the village common is today. In 1863, businessman Joel Tarbell offered the church a lot on the opposite side of the street. The church was moved, turned around, and placed on a better, higher foundation. Over the years, lumber for a belfry was donated by Luther Cram, a weather vane was donated, the interior was renovated, the building was raised, a vestry and kitchen were added, and a spire was built. In the 1970s, the church joined with the Congregational church to form the United Church of Lyndeborough.

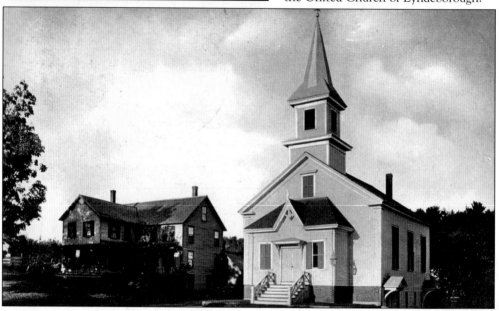

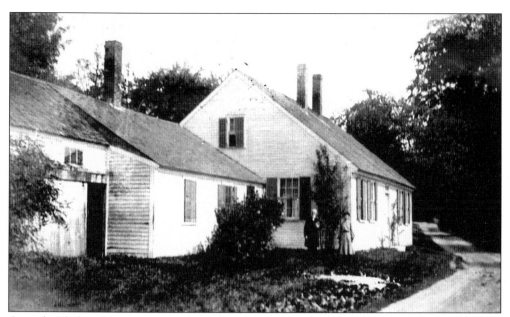

Considered the oldest house in South Lyndeborough, this house was built before 1800 by Daniel Putnam. The first meeting of the Baptist Church was held here in 1829, and the building later became the parsonage. Among the ministers who lived here was Dennis Donovan, author of the 1905 town history. The church sold the building in the mid-1950s. The picture is dated 1905.

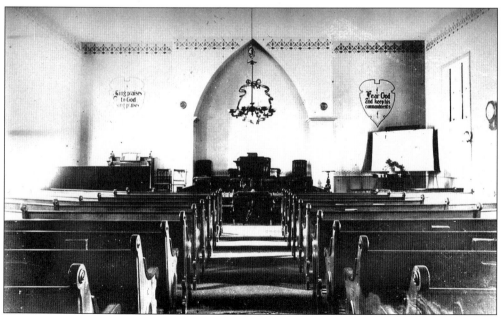

During the early part of the 1900s, the interior of the Baptist church was stenciled. Longtime resident Guy Reynolds recalls the color scheme as brown on tan or cream.

Lanes such the one shown in this postcard view once wandered through pastures and woodlots.

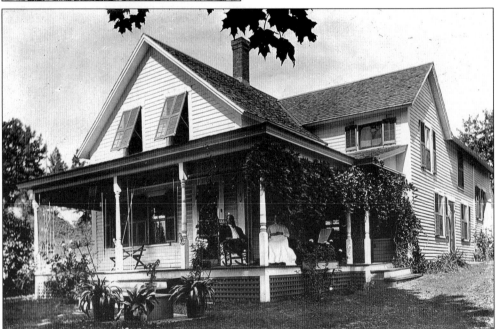

This house on Glass Factory Street was built by J.H. Tarbell. Later owners included Herbert Cheever, Hubert and Eliza Potter, Frank Woodman, and Warren Lord. The house burned in 2000.

98

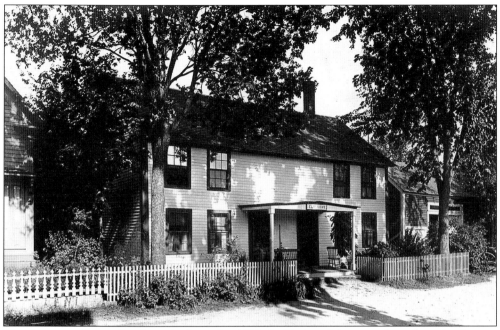

This house on Forest Road was built in the 1880s by Francis Johnson, who adapted it for two families, sharing the house with his daughter and son-in-law. It is still a private residence, but it is no longer a two-family dwelling.

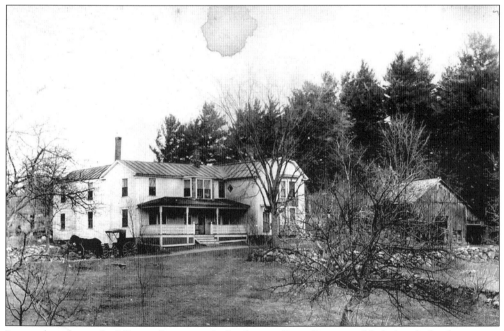

Located at the end of Grove Street, with the former Pine Grove visible behind, this house was built by Albert Cram in the late 1870s. His niece Irene Cram married Walter Patterson, and the family owned the house for some years.

The very narrow trestle shown here on Center Road no longer exists. An edge of the right-hand abutment still shows through the embankment where it was filled in when Route 31 was moved to its present location in 1953.

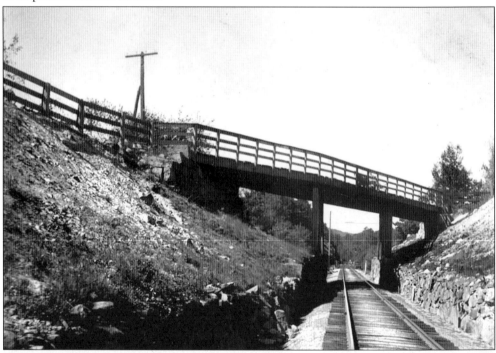

Until 1953, the Forest Road crossed the Boston and Maine tracks on this narrow wooden bridge just west of South Lyndeborough, one of three crossings in less than a mile. In 1953, the present Route 31 was straightened to eliminate two of those crossings. Only the bridge abutments remain at the end of Brandy Brook Road.

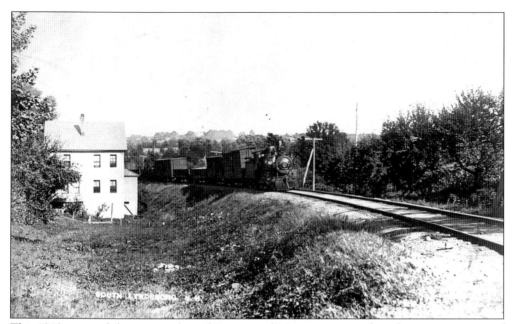

This 1913 postcard shows a westbound Boston and Maine train rounding the corner just east of South Lyndeborough. The house was then owned by Albert Conant. Edward Schmidt Sr., longtime town clerk, later lived there.

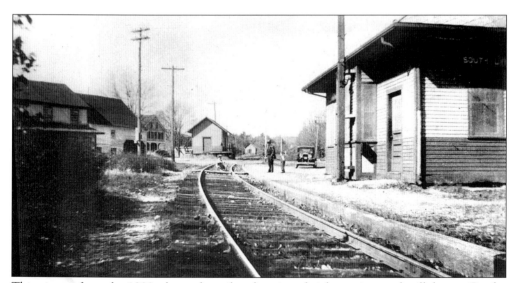

This picture from the 1920s shows the railroad station, freight station, and milk house. On the left, the western end of the village store still has the large door that accommodated the hay and grain business.

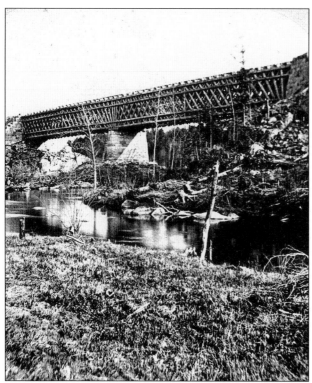

The Peterborough Railroad arrived in Lyndeborough in 1873. The original wooden Gulf Trestle, about a mile west of the village, is shown here in a picture taken from a stereopticon slide made by F.E. Bugbee of Wilton. Some 200 feet long and 70 feet above the Stoney Brook, the trestle was considered an engineering marvel. The wooden structure was replaced in 1888 by a steel trestle with inverted trusses, with supports under the tracks giving it a lacy, airy look. A conventional trestle was installed when the tracks were upgraded to support newer and heavier freight cars.

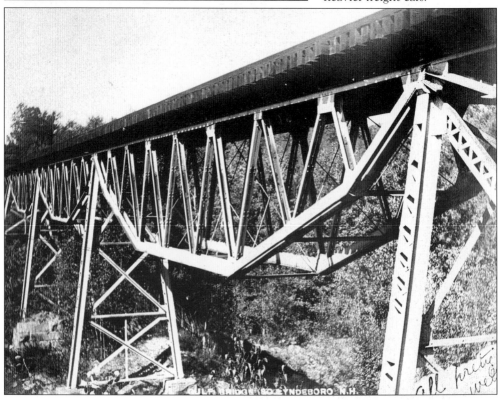

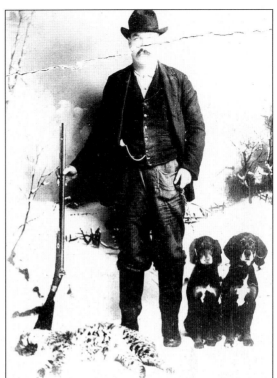

Hunting and fishing have always been popular activities in town. To the right, Sam Dolliver (1860–1917) poses with his hounds and a large bobcat he killed on Lyndeborough Mountain. The Dolliver family came to Lyndeborough *c.* 1775 and purchased an undeveloped tract of land from Jesse Putnam. Below, Guy Reynolds (b. 1912) poses with a selection of beaver skins stretched for curing. The Reynolds family came to town in the 1880s.

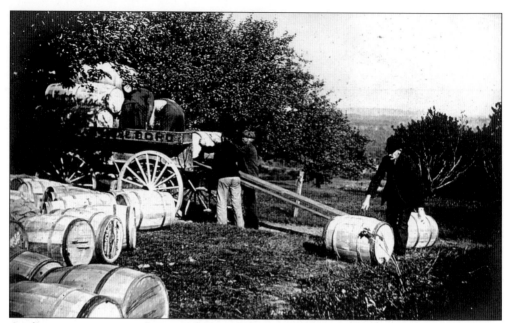

Apples were a major crop for many years. In the early 1900s, apples were grown on most of the town's east- and south-facing hills. They were packed in wooden barrels and shipped by rail to Boston markets. One commercial operation, Woodmont Orchards, remains active in town.

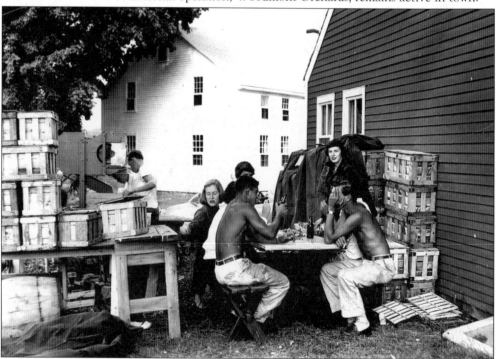

Harvesting wild blueberries, which grew on the mountaintops, was a big business until c. 1950, reaching its high point before World War II, when hundreds of bushels of berries were shipped to Boston by railroad. Shown on a lunch break, these blueberry pickers worked for Charlie Schwartz.

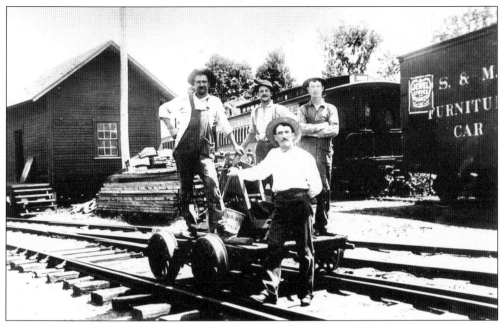

A freight house was located in front of the village store, with a siding between the freight station and the store, which offered hay and grain delivered by rail. Posing on this handcar, from left to right, are the following: (front row) Will Cheever; (back row) a railroad worker, Milo Burton, and Roy Burton.

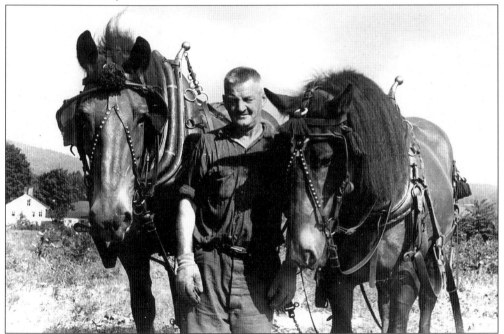

In this 1949 photograph, a teamster poses with his team of horses near the Boutwell house in Lyndeborough Center. James Boutwell settled just east of the town hall in 1767. The property remained in the family for nearly 200 years. The large square house was built by Nehemiah Boutwell and was later remodeled by Charles Boutwell.

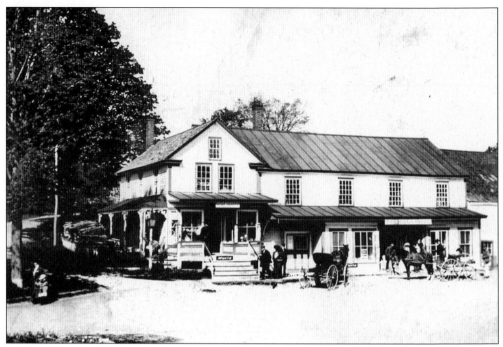

A store has stood on this spot since shortly after the coming of the Forest Road in the 1830s. The post office occupied the gable end on several occasions. The postmaster was a political appointee and changed with the elections. For many years, the store was owned and operated by members of the Tarbell family.

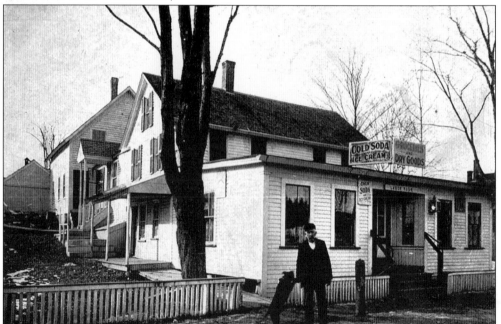

Tarrant M. Beal built the projection on the lower level of this house on the corner of Citizens' Hall Road and the Forest Road, probably in the late 1880s. His store offered groceries, some dry goods, and a lunchroom. The space was used as a post office at least twice.

Once named Winn Mountain Station, this little house on Route 31 and Fay Road was at various times a tea shop, a store, a craft shop, a gas station, and a private residence. Built sometime between 1905 and 1920, it was used by the fire department as a training exercise in 1990, when it was deemed beyond repair.

In 1946, Eugene Muzzey of Greenfield built this small store and gas station on Route 31. It was later owned by William Broderick and then by Julius and Dorothy Sayball. The neighboring house is said to have been made from one of the former railroad station buildings.

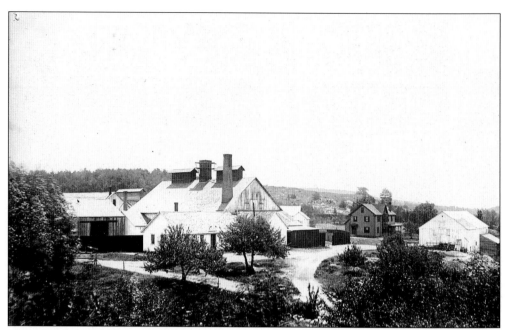

The Lyndeborough Glass Factory operated from 1866 to 1886, producing some of the finest glass in New England, most of it light blue or brown, which is now highly collectible. The factory, located on what is now Glass Factory Road, employed up to 50 people. The quartz used in the manufacture was mined on the hill above the village. The Putnam and Tarbell families were involved in the factory, which never made any money because it could not compete with clear glass made in New York State.

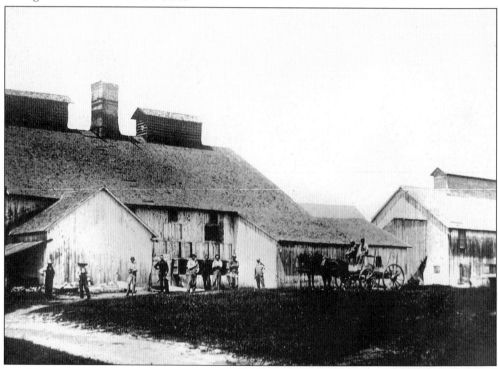

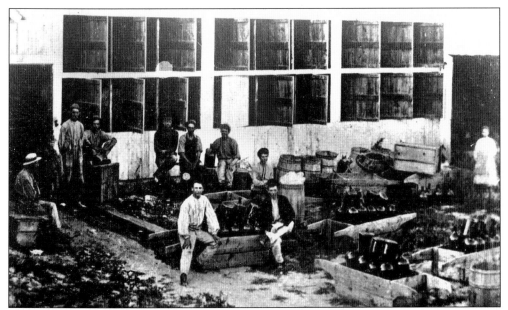

This is one of the few known photographs to show workers at the Lyndeborough Glass Factory. Samples of glass bottles are piled around them.

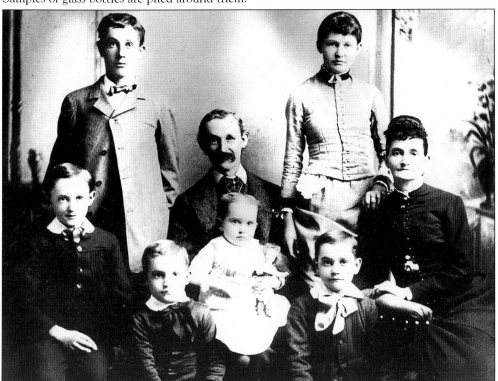

The Putnam family was very involved with the establishment and operation of the glass factory. The Putnams were the last family associated with the factory to live in town. These Putnams, from left to right, are as follows: (front row) James, Mary, and Percy; (middle row) Charles, E.H., and Eliza; (back row) Roy and Lydia.

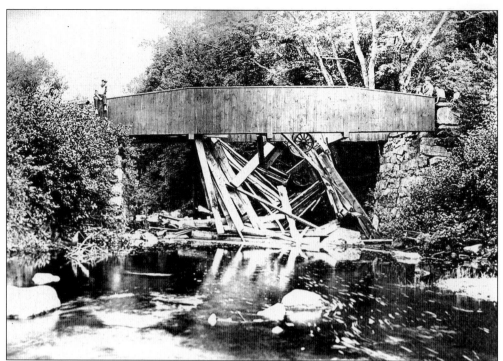

Around 1925, a truck belonging to Blanchard and Langdell Lumber Company of Milford broke through the planking of the Butterfield Bridge in North Lyndeborough. John Proctor happened to be around to take the picture. The truck was pulled out with horses, and the bridge was repaired.

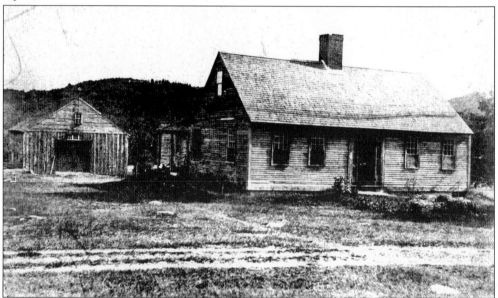

John Proctor, a descendant of the man hanged in Salem as a witch, was one of the earliest residents of the town. He arrived in 1792 and settled in North Lyndeborough. The first house was on the north side of the mountain. John Proctor bought land from a Whitmarsh and built this house, which burned in the 1940s. The present homestead is in another location.

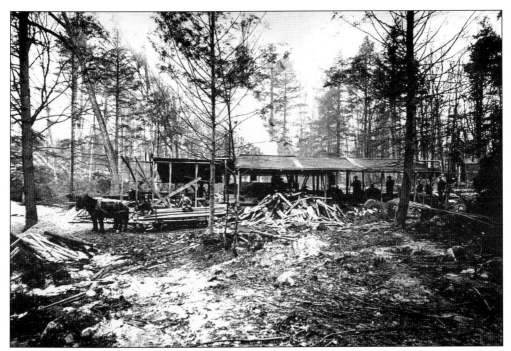

Water-powered sawmills were the first mills built in any new town. This steam-powered sawmill was photographed somewhere in North Lyndeborough by John Proctor before 1910. The mills were moved to the logging site by horses and provided winter work for area farmers. When trucks became available, it was more practical to have a fixed site sawmill.

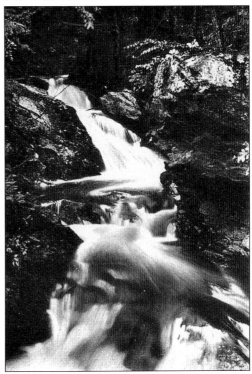

Cold Brook, in North Lyndeborough, tumbles down the side of the mountain in a series of cascades forming Senter's Falls, one of the many scenic areas in town.

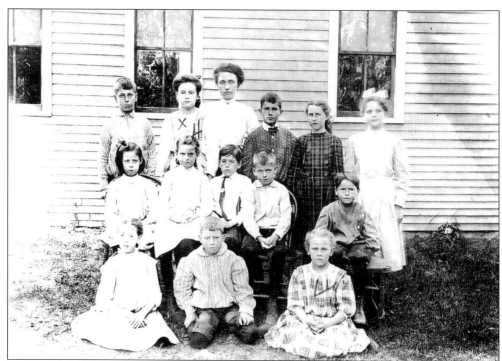

In 1910 or 1911, these students were attending the Perham Corner School. The teacher is Elizabeth M. Parker. From left to right are the following: (front row) Amy Tarbell Felch, Bertrand Wilkinson, and Lilla Chase Stimson; (middle row) Doris Tarbell, Dorothy Batchelder Glasier, Roland Parker, Donald Batchelder, and George Parker; (back row) Carl Batchelder, Hazel Chase Morrison, Elizabeth M. Parker, Harold Parker, Gertrude Wilkinson, and Hilda Wilkinson.

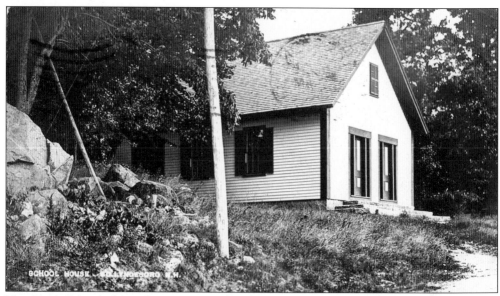

The South School, shown here in 1907, closed in 1949 with the opening of the new Central School. It was one of two one-room schools still in use at the time. It is now a private home.

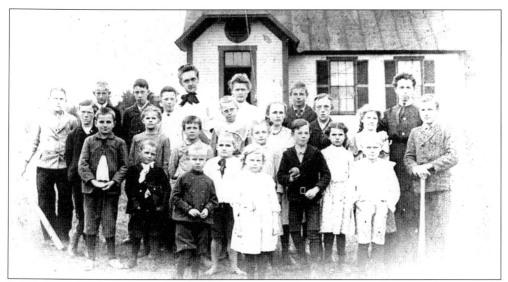

The first school in town was built in the center. This one, built in 1892, closed in 1944. Pictured in 1906, from left to right, are the following: (first row) Donald Baxter, Willie Long, and May Riley; (second row) George Long, Olive Riley, Roy Herrick, Bessie Herrick, George Warren, Nellie Long, and Eddie Long; (third row) Levi Joslin, Cora Bishop, Helen Baxter, unidentified, Ernest Stevenson, Ethel Riley, and Harry Herrick; (fourth row) Everett Joslin, Harold Baxter, ? Boutwell, S. Kate Swinington (a school board member), Almena Kennison, Chester Minot, and teacher Annie Holt.

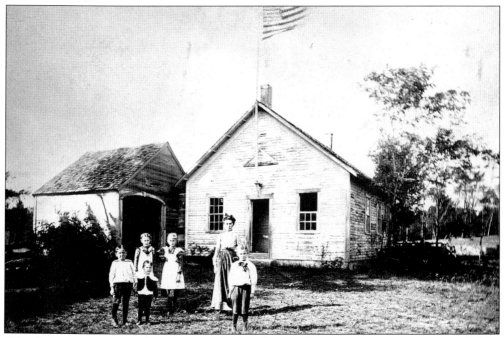

School districts were combined as population decreased and transportation improved. The North School, or No. 4, existed from the 1850s until 1940. Pictured here in 1902 are teacher Annie Holt, with Guy and Charlie Bailey and Percy, Grace, and Hattie Merrill. The building no longer exists.

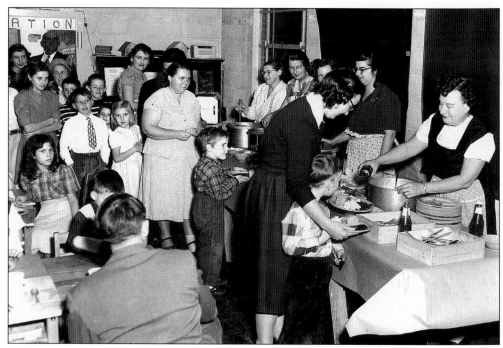

Community dinners, such as this one at the Central School in 1952, were one of the more popular social gatherings. On the right is Helen Meacom, and to the left of her is Dorothy Elliott.

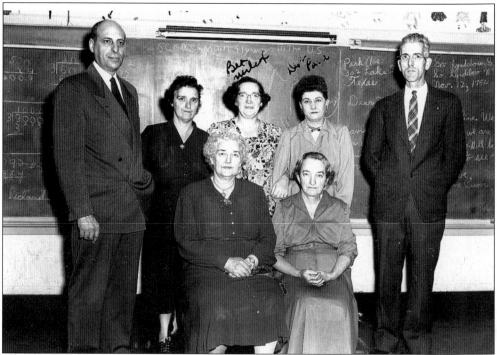

In 1952, there were two teachers at the Central School, Alice Smith and Adelaide Herrick (seated in front). In back are superintendent Newell J. Paire and school board members Olive Bullard, Beatrice Wilcox, Dot Paire, and William Broderick.

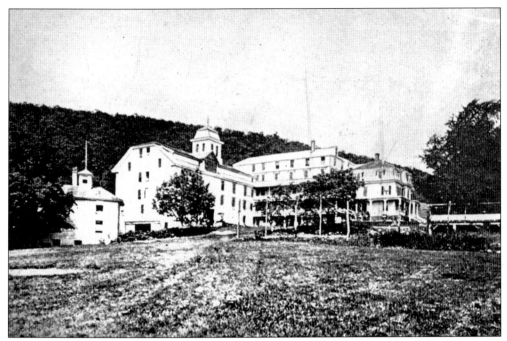

The Pinnacle House, built in 1876 by Edward W. Dunklee on the side of Lyndeborough Mountain, was the town's only summer hotel. It accommodated up to 100 guests and had a billiard room, ladies' parlor, and grand dining hall. It also offered croquet, tennis, fishing, bicycling, and a small golf course. J.T. Stewart was the proprietor when this picture was taken. The unoccupied building burned in 1916.

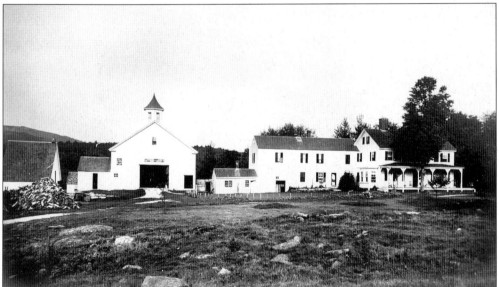

Sweet Brier, on Old Temple Road East, was one of several farms that took in summer boarders. Built in 1800 by Jotham Hildreth, it predates the Forest Road and therefore fronts on "the old road to Greenfield." Humphrey Gould converted it to accommodate guests before 1900, and it continued as a summer boardinghouse into the 1930s. The present house has 13 rooms with eight fireplaces.

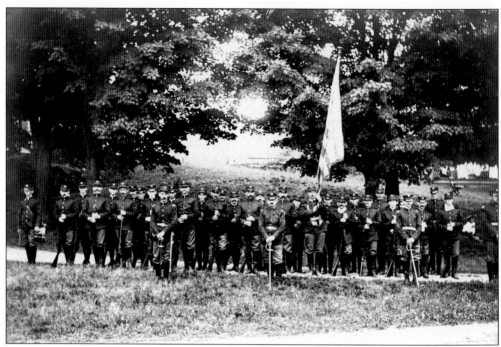

The Lafayette Artillery Company, the second oldest private company in the country, was organized as the artillery company of the 2nd Regiment, New Hampshire Militia, in 1804. The company maintains its 1844 brass cannon in its original condition and fires it on ceremonial occasions. At the outbreak of the Civil War, it was the only serviceable field piece in the state. The company command moved to Lyndeborough in 1833 and, in 1834, chose the present name. During the Civil War, the company had 135 members. These pictures were taken during the company's 100th anniversary in 1904.

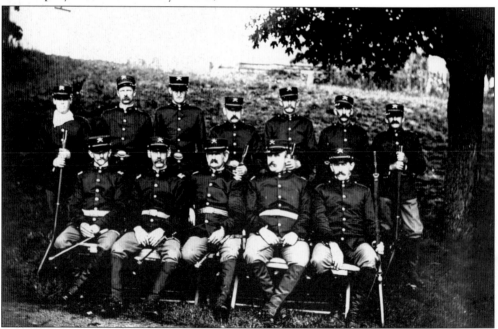

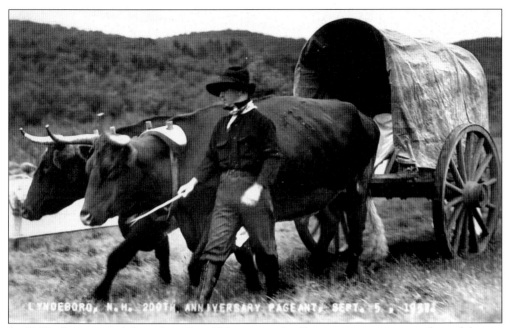

In 1937, the town celebrated its first 200 years with all proper ceremonies and an elaborate pageant detailing the history of the town. In this view, Jason Holt guides a pair of oxen with a covered wagon, one of the pageant reenactments.

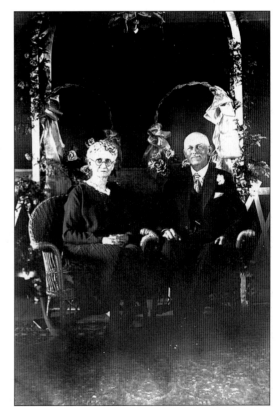

Charles and Emma Perham observed their golden wedding anniversary in 1928. Such anniversaries were frequently celebrated at the town hall or Citizens' Hall as town events. The Perhams lived on a large farm at Johnson's Corner. He died of injuries received in an automobile accident in 1932.

Pinnacle Grange No. 18, Patrons of Husbandry, was formed in 1873, with Andy Holt as the first master. The group met at the town hall for almost 90 years. The Grange held fairs, suppers, and entertainments and supported issues important to local farmers. This picture of a large group of members is undated, and the occasion is not recorded.

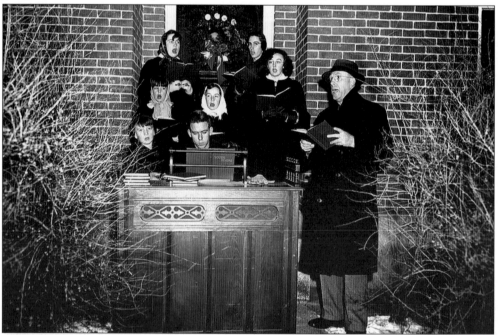

The town's first community carol sing was held in 1952. It was directed by Rev. Sidney Cahoon, with organist Henry Cahoon of the Baptist church. The singers are, from left to right, as follows: (front row) "Skeeter Leavitt," Janet Howe, and Frances Howe; (back row) Libby Howe, Lewis Cahoon, and Norma Walker. The pump organ, used by the Baptist church for many years, has recently been restored.

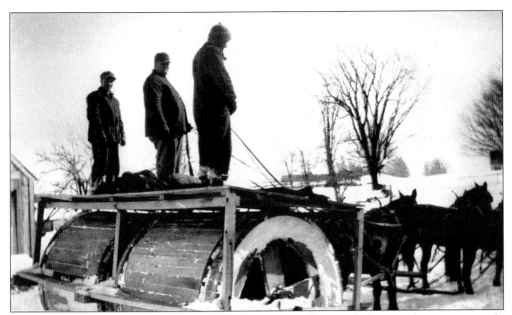

In the 1930s, the town used a snow roller on the town roads instead of a snowplow; many people were still using horses, and sleighs needed several inches of snow for easy going. The men pictured here in the process of "breaking roads" are, from left to right, Harry Herrick, Fred Richardson, and Roy Herrick.

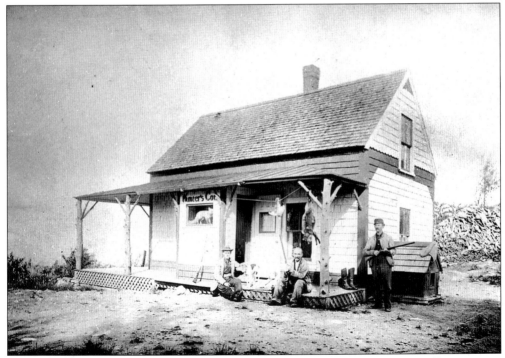

Hunter's Cot is located at the highest point on Mountain Road. Built by Bradley Tay as a summer cottage in the 1880s, it is still a summer home and is considered a landmark.

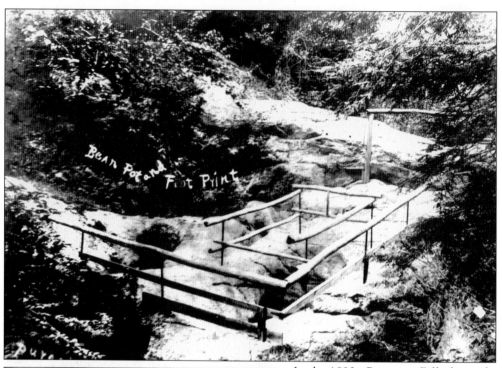

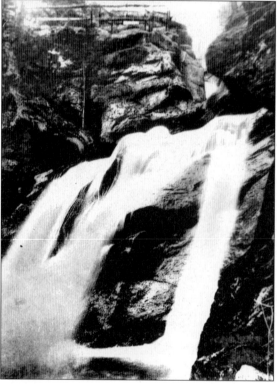

In the 1890s, Purgatory Falls, located on Black Brook on the Lyndeborough–Mont Vernon border, was a popular picnic area, developed by several Mont Vernon men in conjunction with the summer hotels. All signs of bridges, railings, bowling alley, dance pavilion, and other buildings have disappeared except for a few iron rods still in the rock. The falls are now surrounded by the Purgatory Falls Conservation Area, administered jointly by the two towns. Recently, hiking trails were established to the area.

The first New Hampshire man killed in the Civil War was Lyndeborough's Harvey Holt, who died in the first Battle of Bull Run. The Grand Army of the Republic post named for him erected this monument beside the South Cemetery in 1879, honoring the 14 townsmen killed in the war. In all, 110 Lyndeborough men served.

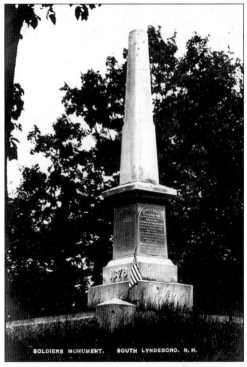

SOLDIERS MONUMENT. SOUTH LYNDEBORO. N. H.

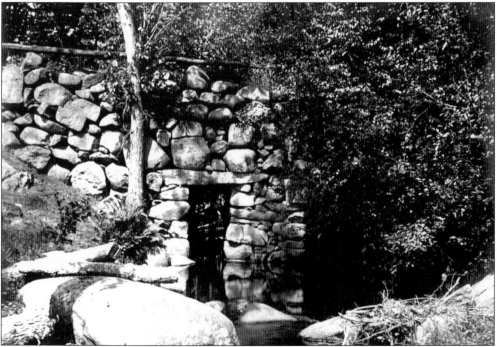

For many years, Furnace Hill Road crossed Furnace Brook on this stone bridge just north of the South Cemetery. The bridge collapsed in the 1970s and was replaced by a culvert. In the early 1800s, a bog iron furnace was located near the bridge, giving the brook its name. It was operated by brothers James and Henry Cram.

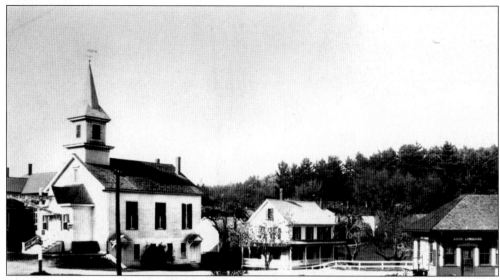

The railroad station on the right was built c. 1910. It replaced an earlier station, shown at the center. The older station had been built for the Lafayette Artillery Company as Armory Hall in the 1860s. It is now the United Church parish house and is connected to the church building.

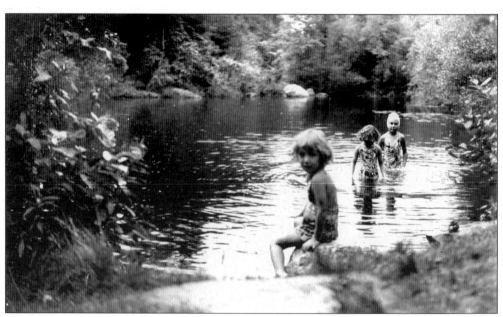

The Eddy is a wide, fairly deep curve in Stoney Brook just west of South Lyndeborough. It was a popular swimming hole for many years and was also used as a baptismal site by the Baptist church. This postcard view from the 1940s shows the area on a peaceful summer afternoon.

The Holt Brothers Orchards, one of the larger operations in southern New Hampshire, was developed by Oliver Holt and expanded by his sons William and Benjamin. The current owners are the fifth generation of the family on this farm but are no longer in the apple business.

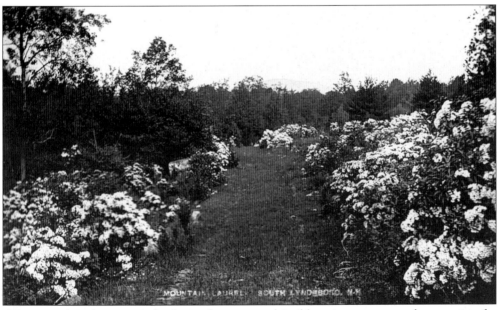

Mountain laurel grows profusely in the area, and its blooming was once the occasion for automobile tours. Village children picked bouquets of the pink and white flowers and sold them to passengers on the trains.

Eli and Susannah (Wilkins) Curtis moved to Lyndeborough from Reading, Massachusetts, in 1769, living first on what is now Beech Hill in Mont Vernon. The family developed what was called the finest farm at Johnson's Corner. Kilburn Curtis (1821–1893) built this house after an earlier home was damaged by lightning. The large barn burned in 1966, and the house was later torn down.

Annie May Curtis (1864–1953), the daughter of Kilburn and Frances (Holt) Curtis, lived much of her life on this homestead. She taught at the Johnson's Corner School in 1906–1907 and from 1913 to 1929.

Rosie Curtis Howe, the daughter of John and Rosie (Holt) Curtis, was born in 1908 and was brought up on the Curtis Farm. In 1929, she married Robert Howe, and she bore eight children. With numerous descendants, she is the current holder of the Boston Post Cane, as the town's oldest resident.

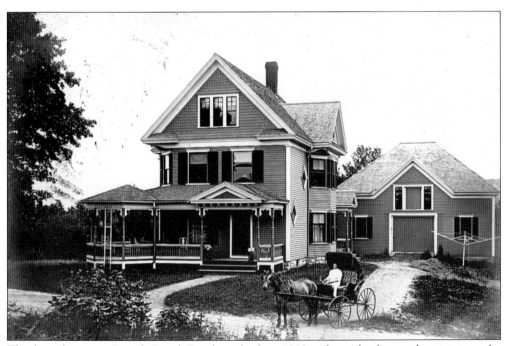

This large house on Brandy Brook Road was built c. 1900 and was the first in the vicinity to be heated by a furnace. Early owners included Minnie Hadley and Oren Wheeler.

The Asa Blanchard Farm, located on Chase Road at Perham Corner, is also known as the Chase Place and the Kellerberg Farm. The house burned in 1954, and Holt Brothers used the barn for apple storage for many years.

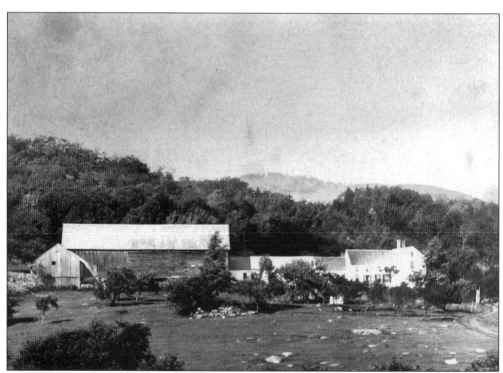

Dr. Benjamin Jones, the first physician in town, was the first settler on this land on the mountainside. He took possession in 1770. It was later owned by Henry Joslin.

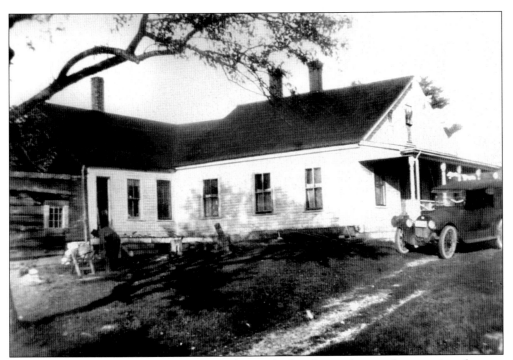

The Frank Reynolds house, on Cram Road, was the last house destroyed in a series of arsons attributed to a local person in the 1940s. Frank Reynolds is shown picking up firewood in front of the house.

Brookhaven, located just off Pettingill Hill Road, was the home of Alice C. Kimball for many years. She was the founder of the Village Improvement Society and was a benefactor of the Tarbell Library. Earlier, the house was the home of the miller at the Bradford Grist Mill, which was located on the nearby brook.

Kenneth Batchelder poses with two other bicyclists. He later became a minister. Bicycling was a customary mode of transportation for young people in the early 1940s, when this photograph was taken.